Ben Nicholson

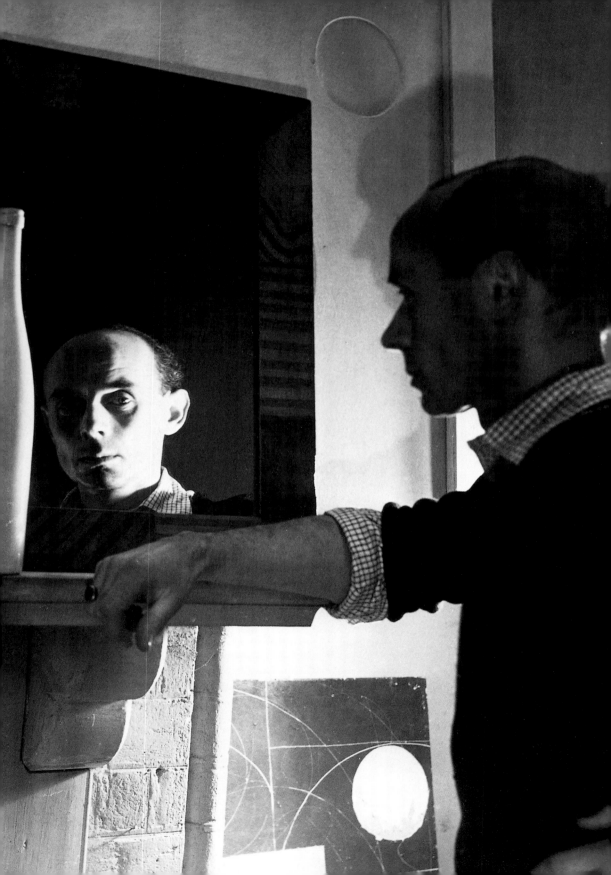

Ben Nicholson

Virginia Button

ST IVES ARTISTS

Tate Publishing

COVER: *1935 (white relief)* 1935 (fig.31), detail

BACK COVER: Ben Nicholson at Casa alla Rocca, late 1960s

FRONTISPIECE: Ben Nicholson by Humphrey Spender, c.1935
National Portrait Gallery, London

First published 2007 by order of the Tate Trustees by Tate Publishing, a division of Tate Enterprises Ltd, Millbank, London SW1P 4RG
www.tate.org.uk

British Library Cataloguing in Publication Data

A catalogue record for this book is available from the British Library

ISBN-13: 978-185437-665-7

Book designed by Caroline Johnston from a template by Isambard Thomas

Cover concept by Slatter-Anderson, London

Printed in Hong Kong by South Seas International Press

Measurements of artworks are given in centimetres, height before width

St Ives Artists

The light, landscape and working people of West Cornwall have made it a centre of artistic activity for over one hundred years. This series introduces the life and work of artists of national and international reputation who have been closely associated with the area and whose work can be seen at Tate St Ives. Each author sets out a fresh approach to our thinking about some of the most fascinating artistic figures of the twentieth century.

Acknowledgements

I would like to thank all those who have generously assisted me in researching and writing this book. In 1993 I had the pleasure of working with Jeremy Lewison on Tate's major retrospective Nicholson exhibition, at which time I gained some acquaintance with both the artist's work and Tate's archival holdings. This book owes a huge debt to Lewison's considerable expertise, his thorough research and his understanding of the artist. Sarah Jane Checkland's recent biography, which meticulously fleshes out the details of Nicholson's life, has also been a useful source, as has new scholarly work by such writers as Chris Stephens, who have challenged established thinking about Nicholson. Where possible within the scope of this book I have attempted to add to their researches.

For their help in the course of my research I would like to thank the following; Alice Strang, Curator, Scottish National Gallery of Modern Art, Edinburgh; Fiona Hackney, Historian of Modern Art and Design, University College Falmouth; Tim Pate and his team, Hyman Kreitman Research Centre at Tate Britain and the Library staff of University College Falmouth. I am especially grateful to Tate conservator Mary Bustin, who generously shared her knowledge of Nicholson's techniques and working methods and Chris Stephens, Senior Curator, Tate Britain, for commenting on a first draft.

I would also like to thank Alessandra Serri, who undertook the picture research, as well as those who kindly assisted sourcing images, particularly Sophie Bowness of the Barbara Hepworth Estate, Marjorie Guthrie, Jeremy Lewison and Jacqueline Ridge. My very special thanks go to the editors assigned to this project, Mary Richards, who managed the initial stages, and Alice Chasey and Rebecca Fortey, who brought it to fruition. Their careful handling and professionalism throughout has been greatly appreciated. Thanks are also due to Emma Woodiwiss for overseeing the production of the book. Finally, I would like to thank my mother, Brenda Hanley, who often took me to Kettle's Yard, Cambridge, where I first encountered Nicholson's paintings.

For my husband Tom Scott

Contents

Introduction 6

1 Life and Work: An Overview 9

2 1930s: The White Reliefs 35

3 St Ives: Abstraction versus Realism in the 1950s 49

4 A Kind of Beauty: Nicholson's Aesthetic Style 65

Notes 75

Select Bibliography 79

Index 79

Introduction

Active for around sixty years, Ben Nicholson enjoyed a long and well-documented career. As a mature artist he was garlanded with international prizes and regarded as an establishment figure, a grand old man of post-war British art. Described by Charles Harrison as England's 'paradigm modernist painter', he has occupied a peculiarly important role in the history of twentieth-century British art.[1] Yet, curiously, Nicholson's reputation has always been somewhat disputed. Even his supporters have sometimes viewed him with ambivalence. For example, Patrick Heron, who came to deeply respect Nicholson's achievement, commented: 'Ben Nicholson is at once an artist of great distinction and originality and yet of peculiar weaknesses and limitations.'[2]

Responses to Nicholson's Tate's retrospective exhibition of 1993, the first major show of his work in London for nearly twenty-five years, exposed a familiar uneasiness about his accomplishment. Was he too clever and intellectual? Were his 'white reliefs' an exception in his oeuvre? Was he in fact a traditionalist rather than a radical? Was his work an expression of spiritual feeling, or was it whimsical, too tasteful and ultimately undermined by a natural facility? Such diverse opinion poses interesting questions for anyone trying to understand or assess his work, not least the present author.

One of Nicholson's undeniable contributions to British art was as a ringleader, playing decisive roles in England's more radical art groupings or 'gangs', such as the Seven and Five Society in the 1920s, the Hampstead Set in the 1930s, and the St Ives School in the 1940s and 1950s. As an advocate of modernism – a 'connector' spreading ideas to effect change – he made a significant impact. He undoubtedly helped to create an environment in which more advanced styles of art could be made and discussed in this country.

Dedicated to forging connections between like-minded people, between England and the outside world, Nicholson was an extraordinarily prolific correspondent. He clearly enjoyed writing, and developed an idiosyncratic, terse and witty style. As he grew older he became increasingly protective of his personal life, destroying documents and coercing friends into returning letters that he wished to keep out of the public domain. Yet his legacy included an archive comprising 7,000 letters, which were acquired by Tate, and many others survive both in public collections in Britain and the United States and in private hands.[3] Over the last decade or so, scholars have begun to make use of this extraordinary resource. This book will draw on what are, for the present writer, the most convincing of such recent researches.

As an introduction to the artist's life and work, it seems appropriate for the first chapter to comprise a biographical overview. Drawing on Tate Archive's exhaustive material, Jeremy Lewison's Tate exhibition catalogue of 1993 has established an accurate, detailed chronology and provided authoritative insight

into Nicholson's dominant themes and influences. My account is largely dependent on this source. More recently, Nicholson's biographer Sarah Jane Checkland has offered a very intimate portrait of the artist. Despite her revealing speculations about the relationship between his art and life, her assessment of his work is perhaps clouded by her impression of Nicholson's failings as a human being.

The influence of Nicholson's parents, both painters, on how he defined himself as an artist in terms of his working practice and his aims, cannot be underestimated. He was married three times, first in the 1920s to painter Winifred Roberts, then to sculptor Barbara Hepworth, with whom he began a relationship in 1931, and from the late 1950s to German photographer and journalist Felicitas Vogler. He lived with the latter in Switzerland until their separation in 1971.[4] These relationships were also important to his artistic development; for example, he acknowledged, 'From Winifred I learned so much about colour, and from Barbara a great deal about form'.[5] Although he often put his work before family and friends, he inspired great devotion and respect from loved ones.

Nicholson's reputation as England's pioneer modernist has rested on his sustained interest in Cubism, and on the work that was met with widespread incomprehension in the 1930s – the abstract 'white reliefs' of 1931–4. Viewed in the context of a modernist art history, this group of works has achieved iconic status. As 'pure' abstractions they have come to represent an unparalleled moment in twentieth-century English art, when indigenously produced art equalled the radicalism of continental modernism. But interpretation of the 'white reliefs' as an heroic tour de force has distorted assessment of his long career, and blinkered thinking about his contribution to a specifically English modernism.

Tate's exhibition of 1993 attempted to counter this narrow focus. But while Lewison's selection and installation were unanimously praised, critical response revealed that the 'white reliefs' were still regarded as the apogee of Nicholson's achievement. It is not my intention to belittle the significance of these remarkable works: their assertive utopianism remains irresistibly seductive in a fractured, post-modern world. But as an introduction to the 'white reliefs', chapter two offers an account that explores their relationship to contexts other than the well-established international modernist one, including, for example, the revival of English craft traditions and the artist's own beliefs – influenced by Christian Science – about what might constitute pictorial reality.

In 1930s England, Nicholson's work exemplified a radicalism that was bound up with his lifestyle and circle of friends and associates, both in Hampstead and Paris. But rather than being simply a strategic 'purist', committed to exploring avant-garde movements such as Constructivism and Cubism, he was also responsive to his particular cultural environment. While he did not consider himself to be a specifically English artist, it seems his understanding of internationalism involved the idea of a dialogue between national sensibilities. Interestingly, his work, when appreciated abroad in the post-war period, was admired for what were perceived as English qualities – linearity, simplicity, restraint. He may well have been uncompromising in his pursuit of an 'idea' in his work, but he resisted typecasting. As an artist he was capable of pure abstraction, figuration, and a fusion of these apparent opposites.

Nicholson was a great traveller, particularly responsive to the landscapes, architecture and ancient monuments he encountered. Drawing was always an important element in his work, and it was through the process of drawing that he got to know an object or place. He lived amongst the fells of Cumbria, in the spectacular mountainous region of Ticino in Switzerland, and made numerous

working trips to Yorkshire, Brittany, Italy and Greece. Yet more important to him than any of these was Cornwall, where he made his home between 1939 and 1958. Chapter three explores Nicholson's relationship with Cornwall, and more particularly St Ives, which by the end of the 1950s was recognised as the home of Britain's 'official' avant-garde. The merging of abstraction and 'naturalism', which characterised Nicholson's work in St Ives, is considered in relation to the post-war critical debate between abstraction and realism.

Between the 1930s and 1950s it was obvious even to those who objected to his work that Nicholson was an artist of real conviction and steely determination. But strongly felt reservations about the validity of abstract art, expressed by such key figures as John Rothenstein, director of the Tate Gallery, hindered Nicholson's acceptance as a serious artist. By the late 1950s, with the international success of American Abstract Expressionism, abstraction – and Nicholson – were finally accepted by the British establishment.

A more enduring criticism has revolved around the issue of Nicholson's aesthetic sense, at once admired for its beauty and discernment, yet condemned as overly tasteful. His lifelong practice of texturing or weathering a surface or support has contributed more than any other factor to the distinctive appearance of his work. Drawing on expertise from Tate conservation, the final chapter speculates on the significance of Nicholson's process of working a surface, which derived as much from the act of his mother scrubbing the kitchen table as from established modernist practice. As a technique it helped him in his ongoing pursuit of a 'primitive' authenticity in his work, a desire to make paintings that might be seen as real objects, rather than artificial constructs. This goal informed all of his work, and most likely had a spiritual as well as aesthetic dimension. While his resolute work ethic and predilection for simplicity and naturalness were consistent with his mother's Puritanism, this chapter speculates on the relationship between Nicholson's aesthetic sensibility and the Japanese concept of *wabi sabi*, which he may have discovered through his connection with the potter Bernard Leach.

Nicholson enjoyed official recognition late in life, but he detested the 'cult of personality', which evolved rapidly with mass communications in the post-war period. He felt that the self-important notion of the artist as celebrity destroyed the child-like vision needed to create truthful work. At the same time he was something of an art-world 'operator' of no small accomplishment. Throughout his life he cultivated relationships with writers, critics and curators who might prove useful in promoting his cause. But although he liked to approve accounts of his work, he was more concerned with how it was reproduced, believing in the power of the image over words.

Often characterised as an intellectual artist, he was in fact passionately committed to the idea of instinctiveness in art, a virtue he came to recognise as inherited from both his parents, and was dismissive of theorising and art-speak. Ironically, his sophistication as a maker of images and objects has made it hard for some to perceive this deep wellspring on which his entire practice drew.

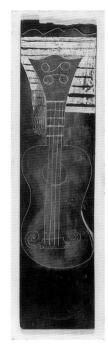

1
1933 (guitar) 1933
Oil on board
83.2 × 19.7

Tate

1
Life and Work
An Overview

Ben Nicholson has often been portrayed as a rather cold, uncompromising character, a fastidious perfectionist committed to only one thing: his work. As even long-standing friend and supporter Margaret Gardiner commented, 'Ben, with his immense charm, his careless elegance, his warmth and generosity, his cussedness and sometimes downright cruelty, his deep seriousness, his jokiness, and above all his utter dedication to his work still remains – as he always was – complex and contradictory …'.[1] In the context of English culture, where for much of the twentieth century the ethos of the amateur held sway, his seemingly puritanical dedication was regarded with suspicion, if not outright hostility.

When he produced his most rigorously abstract works in the early 1930s he was labelled along with them as intellectual and devoid of emotion. In an influential retrospective account of the 1930s art world, Myfanwy Piper confirmed the view of Nicholson and his then wife, the sculptor Barbara Hepworth, as unfeeling zealots in pursuit of 'the lofty beauty of a consistent abstract environment'. According to Piper, who was in part defending her own adoption of an eclectic approach to aesthetics in the late 1930s and 1940s, their art was fuelled by a 'missionary egotism, intense, obstinate', which though inspiring was exclusive and intolerant. But such fixity of purpose also won affection and respect. After Nicholson's death one of his closest friends, Cyril Reddihough, more generously described Nicholson's love of precision as an 'acute sensibility' … 'outstandingly characteristic of him both as an artist and as a man'.[2]

It is tempting for commentators, particularly biographers, to conflate an artist's life and work, to interpret works of art as barometers of personal feeling, or as directly expressive of an individual's character. For example, while Sarah Jane Checkland's recent biography of Nicholson is thorough and engaging, its very title *Ben Nicholson: The Vicious Circles of his Life and Art* issues a damning moral judgement before the reader has turned a page. Although claiming to reassess and celebrate his artistic achievements, Checkland's account of Nicholson's relationships – particularly his treatment of the women and children he 'abandoned' for his career – seems more like indictment than celebration. Ultimately, he is exposed as selfish and uncaring, his life summed up as a 'cautionary tale'.[3]

The notion that art and the character of its maker are inextricably linked has permeated thinking about art and artists in Western culture since Vasari's *Lives of the Artists* viewed artists as custodians of the imaginary, and invested them with a 'moral weight or responsibility unlike that held by any other member of society'.[4] In the context of such interpretative baggage, the reader is left to conclude that there is some kind of direct metaphorical relationship between Nicholson's carved reliefs and what Checkland suggests are the 'vicious circles' of his personal life.

To a certain extent the story of Nicholson's life conforms to the idea of the

artist who sacrifices everything, including familial responsibilities and personal happiness, for the sake of art. He set himself high standards and adopted a disciplined working practice, both of which inevitably caused tensions in his personal and professional life. Yet even if we accept that Nicholson had flaws, this should not detract from an appreciation of the values he attempted to attach to his work, or an understanding of the meanings they accrued in a wider context.

Nicholson established a reputation in the 1930s as an international modernist, an exponent of a detached, 'absolutist' form of abstraction. He remained international in outlook, but during subsequent decades he sought to correct what he felt was a misrepresentation of his practice, which for him was governed by instinct and a desire for freedom, rather than intellect or a set of rules. He was attracted to the pursuit of a spiritual truth in his work, but his understanding of spirituality originated in perception and lived experience, and in the very physical act of making.

He had no desire to become an art world celebrity and so gave few interviews. Nevertheless, his articles and letters suggest that he was supremely conscious of his artistic identity. In his sixties, he listed the influences that had a made a major impact on his development: early Cubism, his years working alongside Hepworth, and Piet Mondrian. But at the top of the list were his parents, and in particular the artistic inheritance bestowed by his mother.[5]

Painting Genes

Ben was born on the 10 April 1894 in Denham, Buckinghamshire, the eldest son of William Nicholson and his wife Mabel (née Pryde). Although both his parents were painters, his mother relinquished her career to raise a family.[6] His home life was relatively unconventional. Not particularly well off, the Nicholsons nevertheless lived in elegantly furnished homes, and were host to regular visitors from the worlds of art and the theatre. His parents' friends and acquaintances included, for example, Lady Sackville, Edwin Lutyens, Max Beerbohm, J.M. Barrie, Rudyard Kipling, Henry Irving, Marie Tempest and Walter Sickert.[7]

William was attractive to women, known as much for his dandyish taste in clothes as for the fluency of his Manet-esque brushwork. He was also something of a prankster, fond of jokes and games. Mabel, the daughter of an Edinburgh

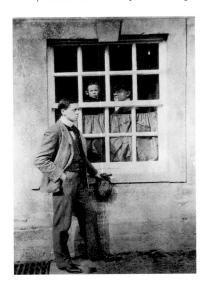

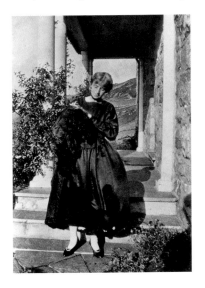

2
William Nicholson outside Chaucer's House, Woodstock. Inside James Pryde carries Ben Nicholson, c.1898

Tate Gallery Archive

3
Mabel Nicholson at Llys Bach, Harlech, c.1916

Tate Gallery Archive

doctor, was related on her mother's side to the Scottish painters Scott Lauder and James Eckford Lauder. Her brother, the painter James Pryde, collaborated with William under the pseudonym 'J. & W. Beggarstaff' to produce a series of French-inspired modern posters, which became highly regarded on the Continent. Although William's reputation rested on his popular woodcuts and society portraits, Ben preferred his father's still-life and landscape paintings.

It was difficult for Ben to avoid being compared with his illustrious father.[8] Writing with the artist's collaboration in 1948, John Summerson suggested that the strength of his artistic purpose resulted from a struggle for independence from 'the kind of painting associated with his father's name'. This struggle honed a 'creative power of an unusual kind: it is the power to deny, discard and eliminate, in pursuit of reality: it is the power to realize a live idea by stripping away the dead ideas which lie around it: it is the power of turning one's back resolutely on the known in order to grasp the unknown'.[9]

For various reasons his relationship with his father was tense and resentful, a mixture of admiration and rivalry. It is feasible to interpret the development of Nicholson's career, on a personal level, in terms of an oedipal struggle, stimulated by a need to define himself against his father's artistic accomplishment.

Deterred by his background, Nicholson was slow to commit to a painting career. In October 1910, aged sixteen, he enrolled at the Slade School of Art, only to leave the following year. Like any adolescent he took his parent's world for granted, by all accounts showing little interest in his studies, instead playing billiards with Paul Nash at the nearby Gower Hotel. The aesthetics of the billiards room apparently had more influence than his teachers: 'The red ivory ball and the two whites, one with a spot and one without, and the clink of their relationships became an "experience" far more related to art than anything they taught at the Slade'.[10] His peers at the Slade included Stanley Spencer, William Roberts, Mark Gertler, C.R.W. Nevinson and Edward Wadsworth, all of whom were to establish reputations by the 1920s. But it took Nicholson a further ten years or so to find his feet. This was partly due to extended trips abroad (to Tours, Madeira, Italy, Switzerland and the United States). Then a series of tragic events forced him to focus on the direction of his life.

He was rejected for active service in 1914 on account of his asthma, and in 1917 his mother sent him to visit relatives in Pasadena, California. Ben never saw her again. She perished during the influenza pandemic in 1918, followed a few months later by his younger brother, Tony, who died from wounds sustained on active service. Within a year his father married Edith Stuart Wortley, a young widow and friend of Mabel's, to whom Ben was unofficially engaged. Understandably, the timing of this betrayal was to turn him against William. By contrast, in death, his mother and all she represented acquired greater significance. Ben began to identify more with her, particularly with her Scottish, 'Celtic' identity. He cast her as the instinctive 'primitive', the opposite of his father's seductive but hollow sophistication, often citing her honest, down-to-earth sense of reality as a key influence on his work: 'Mother's character was a very potent one – she was fanatical and completely uncompromising and had a Scotch purpose and integrity which was the thing that meant most to me in that home life – that & her friendship & the fact that she backed me up completely (quite as completely as father never backed one up)'.[11]

According to Nicholson, his mother's Scottishness, characterised by simplicity and lack of pretension, provided the inspiration for a way of working. In the 1940s he wrote to Herbert Read:

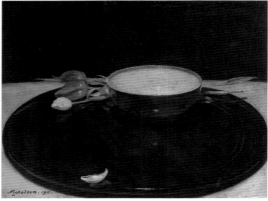

where father's taste ran to panelled walls, Dighton prints, bar parlours and Chippendale furniture … mother … said the only rooms she really felt at home in were the studio, nursery or kitchen – she said that after listening to a lot of talk about art it made her want to go and scrub the kitchen table. Scrubbing the top of a really well used kitchen table is very close to the way I work.'[12]

Yet he undoubtedly shared William's ready wit and dandyish sensibility, as Cyril Reddihough remarked: 'Ben was like his father, fastidious and had style. His shirts and handkerchiefs were always immaculate and they affected one like the crisp sparkle of a sunny morning'.[13]

After his father's death in 1949, Ben was able to assess their relationship more favourably. In 1963 he revealed:

But of course I owe a lot to my father – especially to his poetic idea and to his still-life theme. That didn't come from Cubism, as some people think, but from my father – not only from what he did as a painter but from the very beautiful striped and spotted jugs and mugs and goblets, and octagonal and hexagonal glass objects which he collected. Having those things throughout the house was an unforgettable early experience for me.[14]

Still life came to dominate his oeuvre. Early paintings that survive, such as *1919 (blue bowl in shadow)* (fig.4), show him learning from his father's example, adopting William's sense of compositional simplicity, as typified by *The Lowestoft Bowl* (1911; fig.5), while rejecting the more complex devices, such as the placing of flowers to animate the otherwise elemental composition.[15] Clearly, he was able to exploit the opposing – or complementary – artistic identities both parents offered him.

It has been suggested that his most radical work of the 1930s can be understood in terms of his desire to establish a modern lifestyle, as a means of distinguishing his life from the patriarchal, lavishly decorated Edwardian world of his father.[16] For Ben this process began in 1920, when he met and married the painter Winifred Roberts.

1920s: Winifred, Domesticity and the 'Primitive' Vision

Winifred's parents were Liberal politician Charles Roberts and Lady Cecilia, daughter of George Howard, 9th Earl of Carlisle, a successful painter connected to the Pre-Raphaelite circle; her mother was also an accomplished amateur watercolourist. So Winifred and Ben both came from artistic stock. Winifred offered him genuine companionship and, with a private income of £500 a year, a degree of financial security. His new-found independence was signalled by

4
1919 (blue bowl in shadow) 1919
Oil on canvas
48.2 × 64.7
Private Collection

5
Sir William Nicholson
The Lowestoft Bowl
1911
Oil on canvas
47.6 × 61
Tate

changing his name from Benjamin to Ben, and by the disappearance of his father's influence in his work.

Following their honeymoon, comprising a grand tour of Italy via Paris, the couple hoped to settle in Italy on account of Ben's health. But conditions in post-war Italy were not what they had expected. Eventually they purchased Villa Capriccio, a spacious house near Castagnola in the Ticino, where the climate was perfect. They spent the next three winters there, focusing on their painting, and making brief visits to Paris en route from or back to Chelsea. They often painted and made drawings outside, comparing each other's work at the end of the day. Winifred became well known for her interest in light and poetic sensitivity to colour (see fig.7), which was to have an enduring impact on Ben's work.

Although few of his pictures survive from the early 1920s, Nicholson recalled that this was 'a very important period of fast and furious experiment'.[17] Encouraged by their sculptor friend Frank Dobson, and the painter David Bomberg, who had been associated with the radical Vorticist movement before the First World War, the two young painters began to absorb ideas from the works of modern artists they admired, such as Pablo Picasso, Georges Braque, Henri Matisse and André Derain. They also shared an interest in the direct simplicity of primitive and early Renaissance art and were particularly keen on the work of Henri ('Le Douanier') Rousseau, Piero della Francesca and Giotto.

Ben's first accomplished work, *1921–c.1923 (Cortivallo, Lugano)* (fig.8), most likely painted in the studio rather than outside, shows a lightened palette influenced by both Winifred and Piero della Francesca. It also demonstrates his growing confidence in the handling of the visual language of modern artists like Paul Cézanne, while developing a personal style, involving the use of drawing and the depiction of precise forms. Another key work from this period was painted while staying with Paul Nash in Dymchurch on the Sussex Coast during the summer of 1923, where the two artists painted views from the promenade. Ben's seascape (fig.9) is rendered in what seem like abstract blocks of colour, emphasising the materiality of the paint itself. As in *(Cortivallo, Lugano)*, space is flattened by the introduction of a strong vertical line, in this instance, a breakwater rather than a tree.

With Winifred in Lugano, Ben embarked on a disciplined approach to work that he sustained throughout his career. While their relatively frugal lifestyle echoed the values of William Morris's Arts and Crafts movement of the late nineteenth century, which promoted truth to nature and simplicity in art and life, it most likely represented a reaction against the Edwardian style and habits of their parents.[18] Their taste for plain living was also commensurate with their Christian Science

6
Winifred Nicholson on the terrace overlooking Lake Lugano, *c.*1921

Tate Gallery Archive

7
Winifred Nicholson
Cyclamen and Primula
*c.*1922–3
Oil on paper/board
49.2 × 54.6

Kettle's Yard, University of Cambridge

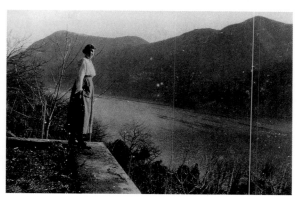

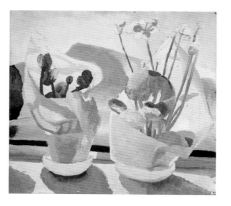

8

1921–c.1923
(Cortivallo, Lugano)
1921–c.1923
Oil and pencil on
canvas
45.7 × 61

Tate

beliefs. Established by Mary Baker Eddy in America in the nineteenth century, Christian Science developed an upper middle class following in England during the 1920s. Ben had first encountered it in Pasadena in 1918, but it was only through Winifred's adoption of the religion that he became interested in its underlying philosophy. Arguing that sin, disease and death could not possibly have been created by God, Eddy concluded that the material world was an illusion masking spiritual truth, and that disease and adversity could be overcome through a greater understanding of spiritual reality through prayer.[19] Winifred, who was thought to be infertile, began to practise Christian Science in 1924 and the conception of her first child in 1926 confirmed her belief. Although Ben's attachment to Christian Science was less practical and consistent than his wife's, it nevertheless provided a metaphysical language with which to articulate his spiritual feelings.[20]

The Nicholsons began to feel that Villa Capriccio was too grand and costly, and although they did not sell it until 1926, their last stay there was spring 1923. By the end of that year they had acquired Banks Head, a house on Hadrian's Wall overlooking the valley of the River Irthing, near Winifred's parents in Boothby, Cumberland. Thereafter they split their time between Banks Head and Chelsea. In London Ben's work was beginning to get attention, and in 1924 he was invited by the painter Ivon Hitchens to join the Seven and Five Society, which provided the first platform and context for his work. Within two years he was elected as the Society's chairman and in this role he began to earn a reputation as an implacable modernist.

In the mid-1920s the Seven and Five Society provided an alternative to the London Group, which was dominated by Bloomsbury, although it similarly promoted a style of art rooted in post-Impressionism. Over the next five years Nicholson strategically introduced artists, notably the young and talented painter Christopher Wood, who he felt would endorse his own modern and international outlook. Distinctly disinterested in theory, Seven and Five Society artists pursued personal themes that evoked a simple, hard-working, primarily rural lifestyle, opposed to the sophistication of the city.[21]

9
1923 (Dymchurch)
1923
Oil on canvas
mounted on board
29 × 38.5
Private Collection

10
Christopher Wood,
Jake and Winifred
Nicholson at Banks
Head, spring 1928
Tate Gallery Archive

11
1924 (first abstract painting, Chelsea)
c.1923–4
Oil and pencil on canvas
55.4 × 61.2

Tate

During the 1920s Nicholson continued to explore Cubism, producing what are probably his first surviving abstract paintings, *1924 (first abstract painting, Chelsea)* (fig.11), which he worked out initially in collage, and *1924 (painting – trout)*. But his understanding of the term 'abstract' concurred with the view current in the English art world – promoted through the highly influential writings of Roger Fry and Clive Bell – that abstraction meant distortion of an object in order to depict its essence. Although it is unclear why Nicholson relinquished this early foray into abstraction, it may have been, as Jeremy Lewison suggests, because although loosely based on real objects, for the artist these compositions seemed too removed from reality.[22]

Although Ben was open to many influences, during the later 1920s the most significant were Christopher 'Kit' Wood, the young, Paris-based friend of Picasso and Jean Cocteau, and the retired Cornish fisherman and 'primitive' painter Alfred Wallis. From 1927, following the birth of their first child, Jake, Ben and Winifred spent most of their time at Banks Head, where Kit visited them in spring

1928. The relationship between Wood and the Nicholsons was mutually beneficial. They painted alongside one another inside and outdoors, producing landscapes and still-life pictures in a naive style, characterised by simplified forms and direct handling of paint (see fig.12). Although the birth of his son may have prompted Ben to celebrate innocence and childhood, Kit, who had been pursuing this kind of imagery in his work for some time, acted as a stimulus.[23] The Nicholsons also began to experiment with Wood's technique of coating the canvas with a thick, quick-drying

12
*1928 (foothills,
Cumberland)* 1928
Oil on canvas
55.9 × 68.6

Tate

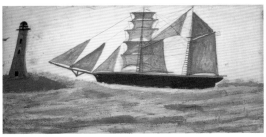

13
Alfred Wallis
Two-Masted Ship
c.1928
Oil and pencil on
paper
30.2 × 59.1

Tate

14
*1928 (Porthmeor
Beach, St. Ives)* 1928
Oil and pencil on
canvas
90 × 120

Private Collection

undercoat of household paint such as Coverine or Ripolin, which produced a textured surface. Incising and scraping down revealed the white undercoat, giving the picture a worn, unsophisticated look, while drawing attention to the painting as an object. The technique of rubbing down is clearly visible in Ben's work of this period: for example, in *1928 (Pill Creek – Cornwall)* (fig.69) the brushmark pattern of the gesso primer shines through layers of scraped-down paint.

In the autumn of 1928 the three painters visited Cornwall, staying in Feock and St Ives. Nicholson's now legendary 'discovery', together with Wood, of Alfred Wallis, is identified as a key moment in the development of modern painting in England.[24] Both painters were impressed by the old man's childlike images of boats and the sea, daubed in household paint from memory on whatever was to hand, including irregularly shaped old wooden boards and card with pinholes (see fig.13). For them, Wallis embodied the idea of the authentically naive painter, and as a true Celt he appealed to their self-conscious exploration of their own Celtic roots. Although they both began to incorporate some of his motifs into their work, Wallis's enduring influence on Nicholson lay not in his subject matter, but in his use of unorthodox materials and supports.

During this period the Nicholsons' marriage came under strain, the birth of their second child, Kate, in July 1929 increasing Ben's sense of feeling trapped by family responsibilities. When Kit died suddenly in 1930, the cracks in their marriage widened. But his artistic influence had already begun to diminish and by the end of the 1920s Ben was poised for a new direction.

1930s: Barbara, Hampstead, Paris and the White Reliefs

In September 1931, a few months after the birth of Ben and Winifred's third child, Andrew, Ben was invited to join a party of artists arranged by the young sculptor, Barbara Hepworth, in Happisburgh, Norfolk. Henry Moore was included in the party and Ben was clearly excited by this encounter with sculptors, as he wrote to Winifred: 'The sculptor's vision is most lovely & most exciting things happen. There is something very magical about the transposing of ideas into form – it is quite amazing'.[25] Happisburgh proved to be a momentous turning point, marking the beginning of Ben's fruitful relationship with Barbara and his affiliation with Hampstead, where a new art community was forming. Soon after his return to London in October he moved from Chelsea to Parkhill Road, Hampstead, near Barbara in The Mall. By spring 1932 they were working alongside one another in her studio. He later recalled that 'everything – in that small Belsize Park space – was bursting with life, you could sense it in the air – it was an enormous adventure …'.[26]

There was clearly a potent chemistry between Ben and Barbara in the early years of their relationship. In May 1932 he wrote to his patron and friend Helen Sutherland that he felt his true marriage was with Barbara: 'Barbara and I are the SAME' … 'with Barbara & me, our ideas, & our rhythms, our life is so exactly married that we can live think & work & move & stay still together as if we were one person'.[27] More overtly than at any other time in his life, images of his lover began to appear in his paintings, often drawn in profile or cast in the elevated role of a queen. Unlike Winifred, Barbara was stylish, ambitious, determined, and apparently emotionally independent; in short, a modern young woman. During the 1930s, they became the undisputed 'it' couple of English art, at the epicentre of an embryonic modernist movement.

The new decade was full of promise and possibility, but Ben's changing personal circumstances were not without complications. Now living with Barbara, he

15
1932 (crowned head: the queen) 1932
Oil on canvas
91.4 × 120

Abbot Hall Art Gallery, Kendal, Cumbria

still felt a deep attachment to Winifred and the children, often leaving Barbara alone. Winifred, devastated by the turn of events, rejected his suggestions that they operate as a *ménage à trois* and withdrew financial support.[28] His letters reassured his wife of her continuing value to him and his work. For example, commenting on his show at Tooth's Gallery, London in November 1932, which he shared with Barbara, he wrote to Winifred, now living on the quai d'Auteuil overlooking the Seine: 'My *first real* expression and so very very much of it is due to you … there is a CLEAR LIGHT in several and some v. simple, living things which you have especially given me … I felt that light when I have found it has come especially from you'.[29] Eventually Ben had to resolve the situation and asked Winifred for a divorce in 1933. She finally conceded in 1938 and Ben and Barbara married. Despite this final schism, Winfred remained devoted to her ex-husband and they maintained a supportive correspondence for the rest of their lives.

It has been suggested that the emotional confusion in Ben's life during the early 1930s found expression in the complexity of his still-life pictures.[30] His attachment to two women is perhaps explored in *1933 (St Rémy, Provence)* (fig.17), in which profiles of Barbara and Ben face one another, while another face

16
Barbara and Ben pulling together, Henley, early 1930s

Tate Gallery Archive

hovering between them has been interpreted variously as their combined reflection in an oval mirror, or as Winifred, the ever-present third party in their relationship.[31] The style of this painting, with its lines incised into a black ground, reveals a debt to Braque, whom Ben met for the first time in Paris in January 1933. The pictorial device of the double profile also indicates his interest in the work of Picasso, whom he visited with Barbara at the Château Boisgeloup, Gisors, on their way home from Provence.

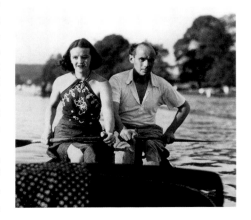

During the early 1930s Nicholson continued to explore Cubist-type picture-making, particularly the depiction of spatial planes. He later regarded a work made at this time, *1932 (Au Chat Botté)* (fig.18) or 'Puss in Boots',

produced after a visit to Dieppe with Hepworth in August 1932, as a precursor to his reliefs. In 1941 he wrote:

About space construction: I can explain one aspect of this by an early painting I made of a shop window in Dieppe though, at the time, this was not made with any conscious ideas of space but merely using the shop window as a theme on which to base an imaginative idea. The name of the shop was 'Au Chat Botté', and this set a train of thought connected with the fairy tales of my childhood and, being in French and my French being a little mysterious, the words themselves had also an abstract quality – but what was important was that this name was printed in very lovely red lettering on the glass window – *giving one plane* – and in this window were the reflections of what was behind me as I looked in – *giving a second plane* – while through the window objects on a table were performing a kind of ballet and forming the eye or life point of the painting – giving a third plane. These three planes and all their subsidiary planes were all interchangeable so that you could not tell which was real and which unreal, what was reflected and what was unreflected, and this created, as I see now, some kind of imaginative world in which one could live.[32]

Winifred's move with the children to an apartment in Paris had been strategic – Ben had recently been told by dealer Daniel-Henri Kahnweiler that no French dealer would consider showing his work unless he lived in Paris. Over the next few years visits to see his estranged family exposed Ben to exciting new developments in the capital of modern art. He got to know many key artists of the

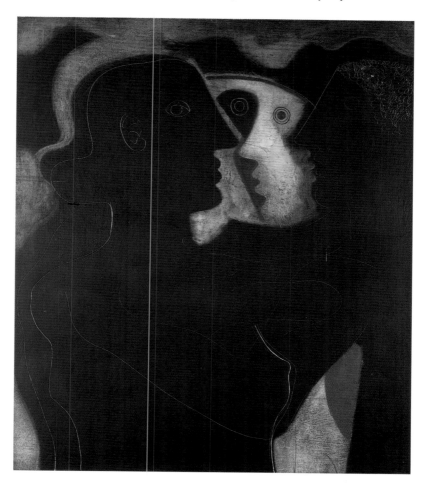

17
1933 (St Remy, Provence) 1933
Oil and pencil on board
105 × 93
Private Collection

18
1932 (Au Chat Botté)
1932
Oil and pencil on
canvas
92.5 × 122

Manchester City Art
Galleries

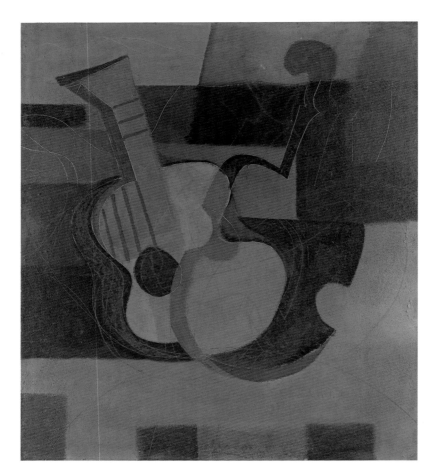

19
1933 (musical instruments) 1933
Oil on board
104 × 90

Kettle's Yard, University of
Cambridge

French avant-garde, including Picasso, Braque, Constantin Brancusi, Jean (Hans) Arp, László Moholy-Nagy, Piet Mondrian, Jean Hélion, Alberto Giacometti, Man Ray and Alexander Calder.

During this period he gradually developed a form of abstraction derived from avant-garde styles current in late 1920s Paris, notably, Surrealism, Biomorphism, Purism and Constructivism. For example, his use of line in painting became less descriptive, closer in feel to Surrealist automatic drawing and the playful lines of Joan Miró (see fig.37).[33] He was also increasingly drawn to the clean lines of constructive abstraction. Such works as *1933 (musical instruments)* (fig.19) show him depicting guitars – one of his favourite Cubist-inspired motifs – against a geometric, abstract background. Then, in 1933, he began to limit his motifs to circles and right angles in accord with universalist styles of abstract art. That year Nicholson and Hepworth were invited by their artist friend Jean Hélion to join the Association Abstraction-Création, founded in Paris in 1931 to promote non-figurative art. In 1932 over forty artists were represented in its first publication, with membership rising to 416 by 1935. Although not all members satisfied the condition that their total output should be abstract, the association nonetheless implied that abstract art could unite an international community of artists, if only around loosely shared aims and ideals.

Nicholson's contact with the French avant-garde and its impact on his work has been well documented. It not only encouraged his development towards

abstraction, but provided a network of contacts, 'a kind of Paris-London liaison', which he nurtured through visits and copious correspondence in an attempt to internationalise the English art scene.[34] His conscientiousness bore fruit in the mid-1930s, when cultural refugees from Nazi Europe were encouraged, thanks to Nicholson and his friends, to settle in Hampstead, briefly transforming a leafy area of London into the hub of European avant-garde activity.

While staying in Paris with Winfred in December 1933 Ben made his first relief, spawning a body of work that consolidated his position as the most radical English artist of the 1930s. He later claimed that the event occurred by accident when a chip fell out of a gesso ground, prompting him to carve into the board he was painting. However, cutting into the picture plane to create spatial depth was entirely in keeping with his interest in Cubist representations of space. Ben also loved drawing. With the reliefs he was using line not simply to represent spatial planes, but to create them.

Several factors led to this development. The influence of Hepworth, with her commitment to the practice of direct carving, and the availability of her sculptor's tools in their shared studio were paramount. Nicholson had enjoyed the process of carving lino blocks for fabric designs with her earlier that year. In addition, his friend the artist and writer Adrian Stokes, was writing enthusiastically about relief carving in *The Quattro Cento* (1932) and *Stones of Rimini* (1934), with Nicholson designing the dust jacket for the latter. He may also have been aware of Giacometti's primitive game-like sculptures of the early 1930s as he compared his own early carved works to children's games.[35]

Like Hepworth's sculptures, the early reliefs have a deliberately handmade quality, with circles drawn freehand and a variety of textures and colours (see fig.36). By spring 1934 Nicholson began to paint his reliefs an even white, and by the summer he was using a ruler and compass, possibly influenced by Mondrian's insistence on precision in his pictorial equivalents of universal, ideal principles. For the next five years Nicholson continued to make white reliefs alongside such coloured abstract paintings as *June 1937 (painting)* (fig.20), figurative drawings and Cubist-style still life pictures.

On the whole, the white reliefs repelled English critics, who found them devoid of human feeling. However, white was hugely significant in the context of 1930s international modernist art, architecture and design, which heralded a new, brighter, cleaner world. Ben admired Le Corbusier's pristine, modern architectural style. He may have read Theo van Doesburg's essay 'Vers la Peinture Blanche', published in *Art concret* (1930), which argued that white was the spiritual colour of the times, a proposition surely consistent with his interest in Christian Science. Nicholson's maiden flight in an aeroplane on 30 December 1933 also had a direct impact, as letters to Winifred link his works to the 'transcendent' experience of flying above white clouds. Another encounter often cited as confirming Ben's association of white with spirituality is his first visit to Mondrian's studio on 5 April 1934 (see ch.2, p.38).[36]

Nicholson's desire to establish an international art scene in London was shared by a number of his contemporaries. In 1933 Paul Nash formed Unit One, a group comprising nine artists and two architects interested in avant-garde ideas, united in their desire to replace an outmoded post-Impressionism, and publicise advanced art to a wider audience.[37] For Nash the group aimed to express a contemporary spirit through the 'pursuit of form' and the 'pursuit of the soul'. But these were contradictory means, representing what were shortly to become the fiercely opposing strands of contemporary avant-garde practice,

20
June 1937 (painting)
1937
Oil on canvas
159.4 × 201.3

Tate

namely abstraction and surrealism. Inevitably, the group was short-lived, however: its first and only exhibition, which opened in April 1934 at London's Mayor Gallery, touring to Liverpool, Manchester, Hanley, Derby, Swansea and Belfast, was a *succès de scandale*, attracting controversial coverage, with Nicholson's abstractions receiving the most negative attention.[38]

Undeterred by disparaging critical response, Nicholson and Hepworth continued energetically to promote abstract art. In September 1935, Nicholson held his first one-person show at London's Lefevre Gallery. Featuring only white reliefs, the exhibition created a furore. The following month the Seven and Five Society, which Nicholson renamed the Seven and Five Abstract Group in 1934, held an exhibition of exclusively abstract work at the Zwemmer Gallery, the first of its kind in England.[39] The group subsequently disintegrated, but for Nicholson it had served its purpose as a forcing ground for abstract art. An opportunity soon emerged for him to show alongside such foreign abstract artists as Calder, Hélion and Mondrian in Nicolete Gray's exhibition *Abstract and Concrete*, held in Oxford, Liverpool, London and Cambridge between February and June 1936. Gray organised the exhibition in collaboration with the journal *Axis: A Quarterly Review of 'Abstract' Painting and Sculpture*, edited by Myfanwy Evans (who later married John Piper). She had founded *Axis* with Piper in January 1935 at Hélion's suggestion as a means of promoting abstract art in England.

Yet the position of abstraction as the most valid contemporary art form was by no means secure. A major blow was dealt in 1936 with the launch of the International Surrealist Exhibition in London's Burlington Galleries, and Herbert Read's apparent championship of 'super-realism', the pursuit of truth through irrational means. In response, Nicholson and his allies produced *Circle, An International Survey of Constructive Art*, edited by Nicholson, Naum Gabo and architect Leslie Martin, proclaiming 'a new cultural unity'. 'Constructive' soon came to replace the term 'abstract' for those adhering to the kind of abstract

art that opposed surrealism, as it described a commitment to ideas rather than emotions. The editorial statement of *Circle* took the form of an article by Gabo, 'The Constructive Idea in Art', in which he aligned the constructive idea to the notion of a universal human 'creative genius', in contrast to Russian Constructivism, proposed by Vladimir Tatlin, which harnessed art to social and economic forces and the 'construction' of society.[40] Nicholson often spoke of his pursuit of a 'right idea' in his work and was happy to adopt the term 'constructive idea' to express this, although during the 1940s he was careful to distance himself from the notion of a Constructivist movement which had Russian and therefore totalitarian associations.

In the later 1930s his reliefs and paintings acquired a new rigour, probably owing to Mondrian's example. Close in spirit to continental modernism's more 'absolutist' strain of abstract art, these works appeared to bring the relationship between art and design to the point of synthesis, with Nicholson becoming, in the words of Leslie Martin, 'a workman in the formation of a new culture'.[41] But despite this apparent severity, Nicholson's work often retained a hint of the natural world, of a table top, a still life, or a distant landscape view. This tendency would increase after his evacuation to Cornwall with his family on the eve of the Second World War in September 1939.

The Nicholsons stayed initially with their friends Adrian Stokes and his wife Margaret Mellis at Little Park Owles in Carbis Bay, near St Ives. Of the immigrant artists among their Hampstead friends, only Gabo remained in England for the war, following them down to Carbis Bay. Such change in circumstances was devastating for Nicholson and Hepworth. All hopes of international cultural unity and of building a better world were dashed, and the security and support of an active intellectual and artistic community evaporated. Abstract art was now considered to be the least internationally acclaimed of all modern art forms.

1940 and 1950s: War, St Ives and International Status

For Nicholson and Hepworth, as for many, the war years brought hardship and isolation. As abstract artists they were excluded from earning any living as war artists and were almost entirely dependent on the generosity of others for their survival. Events dictated a taste for more traditional, reassuring forms of art, and the already limited market for abstract painting virtually dried up. In desperation Nicholson began to produce Cornish landscape paintings, which provided some kind of income. He was ambivalent about this return to nature in his work, describing his landscapes as 'Cornish best-selling schemes'. But the Penwith Peninsula nonetheless had an immediate effect on the development of his work, contributing to his reinterpretation of the still-life theme, which dominated his output in the late 1940s and 1950s.

During the war years Nicholson used what meagre time and resources were available to keep his ideas alive by working in all of his previous idioms. He often drew or painted from windows overlooking rooftops, harbours and landscapes, renewing a device he had first employed in the 1920s derived from Cubism and Fauvism. In these window scenes he began to combine interior still-life groupings with exterior landscape, as in *1944 (Higher Carnstabba Farm)* (fig.21).

The move to a large studio in St Ives in 1949 enabled him to work on a more ambitious scale. Here his Cubist-inspired treatment of still life and landscape became increasingly complex in terms of spatial relations, leading to a series of sophisticated still lifes that re-established his reputation in the post-war period. In these paintings objects are drawn in outline as flat shapes, overlapping with

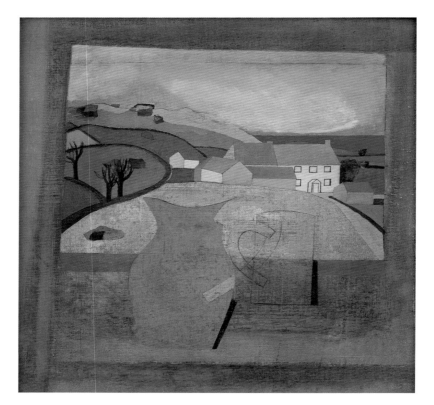

21
1944 (Higher Carnstabba Farm)
1944
Oil and pencil on canvas laid down on board
55.9 × 55.9
Private Collection

each other in complex, rhythmic arrangements similar to the relationship of planes carved into the reliefs. The series culminated in the late 1950s with such monumental paintings as *August 1956 (boutique fantasque)* (fig.22), in which the table-top assemblage seems placed outside against a blue sky and a white building.

The presence of Nicholson, Hepworth and Gabo in St Ives influenced a younger generation of artists. During the war they interested a number of artists in constructive abstraction, although a group was never established.[42] However, once hostilities were over, Nicholson and Hepworth extended their influence in St Ives through the Penwith Society of Arts in Cornwall, which they instigated in February 1949. As a platform promoting 'advanced' art, it became their new power base. Despite some resentment within the art community, their presence in St Ives helped transform the picturesque fishing town into a centre for avant-garde art in the 1950s. Nicholson was generous in sharing influential contacts with younger artists and his example inspired a new level of professionalism in their work. His development of a modern style of painting that was abstract yet with the feeling or presence of nature was particularly important for younger artists such as Peter Lanyon, Patrick Heron, Roger Hilton and Terry Frost, all of whom became identified with a school of modern painting in St Ives that won international acclaim.

In the 1950s Nicholson received numerous prizes which helped to confirm his position as one of the leading international artists of his generation. After the war, along with Moore and Hepworth, his work was promoted abroad by the British Council through such vehicles as the Venice Biennale, where he won the Ulisse prize in 1954. He also consolidated a market and critical recognition for his work

22
August 1956 (boutique fantasque)
1956
Oil, gesso and pencil on board
122 × 213.5
Private Collection

in America, which by the mid-1950s was establishing itself as the new home of the avant-garde. In 1952 he received the prize for painting at the 39th Carnegie International for *December 5, 1949 (poisonous yellow)* (fig.23), followed in 1956 with first prize at the prestigious International Guggenheim Painting Competition for *August 1956 (Val d'Orcia)* (fig.53) and the International Prize for Painting at the 1957 São Paulo Bienal. Such accolades, combined with a major retrospective at the Tate Gallery, confirmed his reputation as a senior figure in the world of modern art. For the first time he became financially secure, although his new-found wealth had little effect on his relatively abstemious, work-driven lifestyle in St Ives.

In conjunction with this extraordinary burst of creativity and acknowledgement, Ben's personal life was tumultuous. In the years immediately following the war, Barbara's health became increasingly fragile, undermined by long-term exhaustion, chain-smoking and the pressure of her blossoming career. Feeling burdened by domestic commitments and Barbara's demands on him, Ben began trying to detach himself from his family. In 1948 he welcomed the first monographs published on his work, one by Penguin Books, which he hoped would explain his work to a wider audience, and a more lavish publication produced by Lund Humphries. That year Penguin also produced a monograph in the same series on William Nicholson, whose death in May 1949 was significant for Ben. Realising that he had succeeded in becoming as accomplished as his father, if not more so, allowed him to reassess their relationship in a more positive light. He must have softened his judgement of his father's infidelities, as he, too, was succumbing to his father's flaws.

In 1950 he began an affair with Rhoda Legge, a married woman more than twenty years his junior who had studied at Penzance art school. The relationship lasted on and off for six years, punctuated with periods of separation when, driven by remorse, Rhoda returned to her husband. The affair brought Ben's marriage with Barbara to an end and after years of bitter arguing and rivalry, they

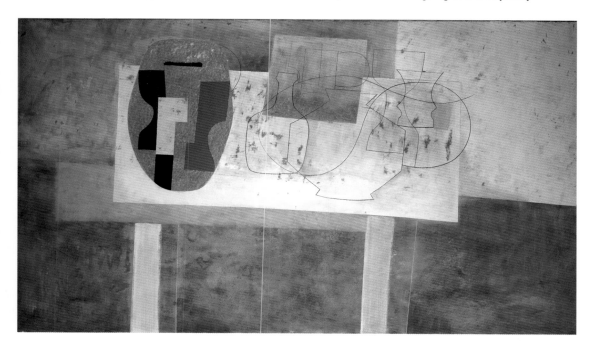

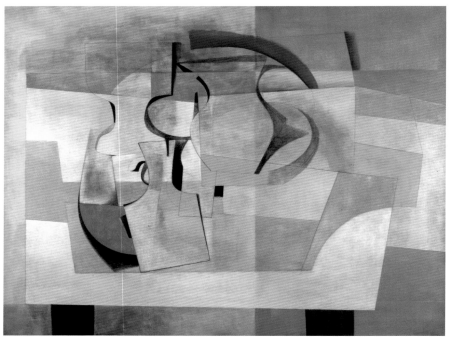

23
December 5, 1949
(poisonous yellow)
1949
Oil on canvas
124.4 × 162.5

Galleria Internazionale
d'Arte Moderna di Ca'
Pesaro, Venice

divorced in November 1951. Barbara's career was advancing at a faster pace than Ben's; for example, she was shown in Venice by the British Council in 1950, four years before him. She felt that his professional rivalry was at the root of their problems, writing to their friends Hartley Ramsden and Margot Eates:

I think he is deeply jealous of my work but its [sic] against his principles to be so – so he represses it & it comes out in a million unconscious acts of putting me in the wrong. The more it continues the longer it takes me to do the days [sic] work consequently I'm tired and his complaint that work absorbs me is true![43]

24
Ben Nicholson and
Felicitas Vogler at
Victor Pasmore's
exhibition, Venice,
June 1960

Tate Gallery Archive

Despite their separation, while they both remained in St Ives it was difficult for either of them to sever their marriage completely. Like Winifred, who never remarried, Barbara remained devoted to Ben, hoping that one day they would be reunited.

But reunion eluded both, as in May 1957 Ben met, and within a few months married, Felicitas Vogler, a young German writer who visited St Ives to research a broadcast about the artist's colony for German radio. Only thirty-five years old compared to his sixty-two, Felicitas was a student of graphology and astrology

25
View of Italy over Lake
Maggiore from Casa
alla Rocca

Tate Gallery Archive

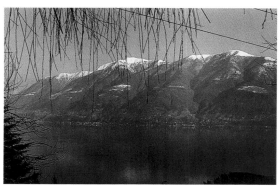

and apparently, like Winifred, endowed with psychic ability. After their marriage she developed her career as a photographer, playing an important role in documenting Ben's work. Realising that he could not remain in St Ives in close proximity to Barbara, Ben moved with his new wife to Switzerland in spring 1958, to a house outside Brissago, above Lake Maggiore in the stunning mountainous landscape of the Ticino, where he had started out with Winifred nearly forty years previously.

1960s: Switzerland and the Late Reliefs

Now in his early sixties, comfortably off and with his reputation secure, Nicholson completed his impressive series of still-life paintings only to enter a new and physically demanding phase of work centred on the production of large, carved reliefs. By his seventies, he was making the most monumental works of his career.

Ever sensitive to his environment, the scale of these new works, such as *Feb 1960 (ice-off-blue)* (fig.26), was possibly stimulated by the mountainous views from his lofty home, Casa alla Rocca, looking east across Lago Maggiore. That the drama of the landscape made a deep impression is clear from an interview he gave to *The Times* in 1959:

St Ives and its surrounding sea and landscape did indeed, I hope, have an effect on my work. Living here in Switzerland also is most stimulating to my work ... The landscape is superb, especially in winter and when seen from the changing levels of the mountainside. The persistent sunlight, the bare trees seen against a translucent lake, the hard rounded forms of the snow topped mountains, and perhaps with a late evening moon rising beyond in a pale, cerulean sky is entirely magical with the kind of poetry which I would like to find in my painting.[44]

26
Feb 1960 (ice-off-blue)
1960
Oil on board
121.9 × 182.9

Tate

Nicholson's enduring commitment to the process of making is exemplified in these heavily worked reliefs. Fearful of losing his sense of purpose, he relished

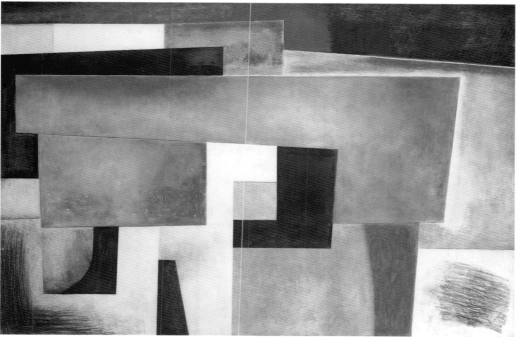

the considerable effort required to produce such impos-
ing objects, which he continued to carve himself, their
sheer size forcing him to work over them on the floor.
This manual labour served to reinforce his belief in truth
to materials, a modernist idea he had begun to explore
alongside Hepworth and Moore in the 1930s. Working
on a relief for ten hours at a stretch involved an intense
state of concentration – almost meditation – in which an
idea could be realised.

These late, abstract reliefs, worked and coloured like
weathered stone, perhaps fulfil the ambition of the white
reliefs made thirty years previously. Unlike the white
reliefs their elements are less rigidly geometric, and
often arranged as a series of interlocking forms to pro-
duce a dynamic tension rather than a feeling of serene
equilibrium. Yet it seems that in both series of works he
was seeking to convey an idea of spiritual truth.

Nicholson continued to think about his reliefs in
architectural terms, but now pre-war, utopian modernist
architecture gave way to the influence of Europe's historic architecture, which he
enjoyed drawing on his many working trips to Italy and Greece. His feeling for
particular places was acute, and perhaps attuned by his third wife's astrological
leanings. For example, he claimed: 'I have favourite places – Patmos, Santorini,
Mycnenae, Pisa and Siena, for instance – and I feel that in a previous life I must
have laid two or three of the stones in Siena Cathedral, and perhaps one very
large one at Mycenae'.[45]

Of greater resonance was his experience of ancient monuments in Cornwall
and neolithic standing stones in Carnac, Brittany, which he had first visited in
1949. Although he never made drawings of the dolmens and menirs at Carnac,
they obviously made a lasting impression. He wrote to Herbert Read in 1963:

Have you ever been to Carnac & Morbihan? [Morbihan] is a most strange & beautiful
place – feels like some spot at the end of the world & with stone circles under water in
the bay & [dolmens] above water … One gets there a tremendous feeling one never gets
in the USA of tremendous events having happened in the past & as if the shape of the
land had been made by events.[46]

The stones embodied a sense of primitivism that appealed to Nicholson, a sense
that he felt he could only achieve in his own work through the format of the
carved relief, as John Russell explained:

He spoke recently of the way in which primitive painters attempted to realize in their work
'some experience, something not on the surface but as deeply embedded in the material
as in himself.' Making reliefs is for him, an in-going, down-going, uncovering affair: the
very reverse of the additive activity of the traditional painter.[47]

Clearly he aimed to imbue his late reliefs with the kind of transcendental quali-
ties he perceived in Europe's time-weathered monuments and stones. This was
partly achieved by the integration of colour with the support rather than simply
laying it on top, as he explained in 1955:

In a painting it should be impossible to separate form from colour or colour from form as
it is to separate wood from wood-colour or stone-colour from stone. Colour exists not as
applied paint but as the inner core of an idea and this idea cannot be touched physically
any more than one can touch the blue of a summer sky.[48]

The grand scale and weathered surfaces of the late reliefs, scoured and

27
*May 1957 (Siena
Campanile)* 1957
Pencil and oil wash on
paper
48 × 37

Private Collection

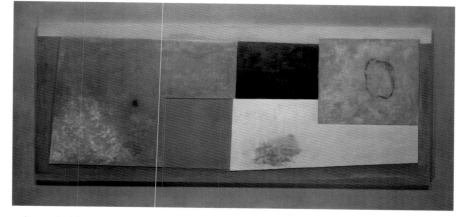

enlivened with earthy colours such as moss green or terracotta, suggest a strong relationship to landscape and to the stones themselves, although reference to specific places in the title is suggestive rather than literal. *1966 (Zennor Quoit 2)* (fig.64), for example, seems to evoke the mountainous landscape around Brissago as much as the Cornish standing stone which gives it its name.⁴⁹

Nicholson's continuing interest in the relationship between art and architecture culminated in the 1960s with his idea for enormous concrete relief walls, positioned in the countryside, against the sea or offsetting a modernist building. The project was realised in June 1964 when he was invited to build a relief wall 4m high and 15m long, overlooking a temporary pool at Dokumenta III in Kassel, Germany (fig.29). Subsequent plans to recreate the wall as a permanent installation remained unfulfilled.

In the 1930s Nicholson had been a leader of a peer group eager to make art relevant to the contemporary world. By the 1960s individual artists like Moore, Hepworth and Nicholson, emerged to forge independent solo careers. Typically, their work was seen to stand alone, not contingent on passing trends. For example, attempting to distinguish Nicholson's reliefs of the 1930s and 1960s, John Russell argued that although Nicholson had artist friends living near him in Switzerland – including Jean (Hans) Arp and Mark Tobey – there was no question of there being any interdependence in terms of their work. When working on a relief Nicholson was now, he proposed, 'outside place, outside time and outside generation-idea'.⁵⁰ Yet, Nicholson maintained his network of contacts. Now residing in the centre of Europe his relationships with other artists were international.

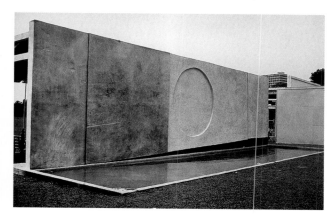

His friendship with Braque of thirty years continued, and new friends emerged, such as the German painter Julius Bissier who settled in Ascona in 1961. The meditative, spiritual nature of Bissier's work, based on an interest in oriental thought, dovetailed with Nicholson's thinking at this stage of his life.⁵¹

In the 1960s Nicholson was offered the CH (membership of the order of the Companions of Honour), which he refused, telling his family with characteristic wit that he had written to the

Palace to decline, explaining that in Switzerland his car already had one. However, when offered an OM (the Order of Merit) in 1968, he welcomed the honour, genuinely pleased with the recognition it signalled. But despite his success and the comforts of life in Switzerland, there is evidence to suggest that he felt homesick for the landscape and seascapes of Cornwall.[52]

1970s: Homecoming

Early in 1966 Ben discovered that Barbara had cancer. Some of his oldest friends – Marcus Brumwell, Read and Stokes – were also fighting potentially fatal diseases. During this period his relationship with Felicitas began to break down. They separated in May 1971 when he returned to England, choosing to live outside Cambridge close to his friend Leslie Martin.

During the 1970s Nicholson continued to produce reliefs, but as he grew older his output decreased and drawing became the focus of his activity. During this last phase of his life he was accompanied by friends on drawing trips both at home and abroad, often by the artist Angela Verren Taunt, whom he met in Cambridge and who became a confidante and companion. He often spent long periods of time studying a landscape or an object before rapidly committing his perceptions to paper. Many of his late works were drawn on irregular-shaped supports, and often, as *April 22 1979 (ivory)* (fig.30), executed using black Japanese felt-tip pens.

Feeling out of place in Cambridge, in 1974, aged eighty, he moved back to Hampstead. In May 1975 Barbara Hepworth died tragically in a fire at her studio. Winifred died at Banks Head in March 1981. By the early 1980s Ben's own health began to fail. Nevertheless, he managed to produce forty paintings in 1981, to be shown at the Waddington Gallery, London, in March the following year. But he did not survive to see his exhibition. At the beginning of February 1982 he fell into a coma. Attended by his daughter Rachel, he died a few days later.

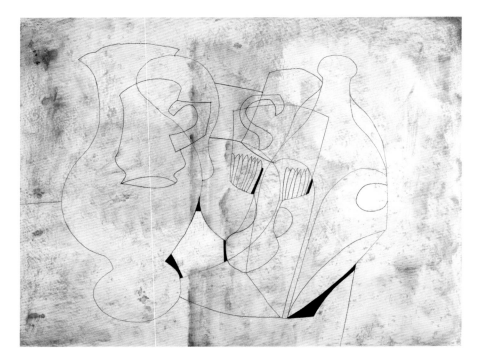

30
April 22 1979 (ivory)
1979
Pen and oil on board
79.7 × 104

Fitzwilliam Museum,
University of Cambridge

2
1930s
The White Reliefs

One of the main differences between a representational and an abstract painting is that the former can transport you to Greece by a representation of blue skies and seas, olive trees and marble columns, but in order that you may take part in this you will have to concentrate on the painting, whereas the abstract version by its free use of form and colour will be able to give you the actual quality of Greece itself, and this will become a part of the light and space and life in the room – there is no need to concentrate, *it becomes a part of living.*[1]

Between 1934 and 1939, alongside his Cubist-style still-life paintings and figurative drawings, Nicholson produced a remarkable series of geometric abstractions, the white reliefs. Combining painting and sculpture, these compositions of squares, circles and rectangles are carved from solid pieces of timber in formats ranging in scale from a few square inches to about twenty square feet. At no other point in his career were his works so apparently pared down, radically emptied of reference to the natural world.

Interpreted as exercises in rigorous formalism, the white reliefs represent the highpoint of Nicholson's achievement as an international modernist. Recent critics have viewed them as an aberration in his oeuvre, an exciting hiatus between his landscape and still-life themes and semi-abstract idioms, as Waldemar Januszczak has commented:

Nicholson exists in our imagination as the creator of a puritanical abstraction, of dramatically sparse, all-white reliefs and coolly intersecting coloured rectangles. In truth, those paintings are exceptional in his oeuvre, confined to a wonderfully brave outburst from the mid-1930s to the early 1940s … For the other 50 years of his working life, he wavers between whimsical figuration, and his achievements become hit and miss.[2]

A more rounded view of these powerful and intriguing works needs to reconsider them both in relation to the artist's oeuvre as a whole, and in the context not only of the Paris-based avant-garde, but the development of a specifically English modernism during the inter-war years.

During the early 1930s, eager to make a significant contribution to international modernism, Nicholson was searching for ways in which to realise his idea of 'pictorial reality'.[3] At this time he developed a network of friends and colleagues in Paris, and his promotion of international abstract or 'constructive' art in Britain helped to make London an attractive haven for European cultural refugees in the mid-1930s. Understandably, his abstract paintings and reliefs have been aligned to this cosmopolitan community. As John Russell has noted:

The people who had come to London … were people who had genuinely re-thought the nature or their environment … as social objects BN's reliefs belong to a new world which had been begun by Gropius and Mies van der Rohe and Mondrian and not to the world which was still waving a last farewell to the nineteenth century.[4]

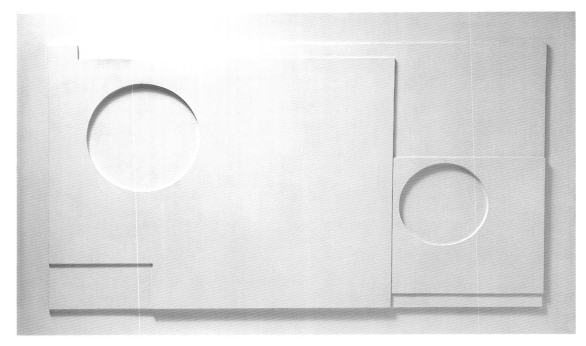

Yet to view these works exclusively in relation to the forms of the international modern movement is too simplistic.[5]

Preoccupied with craft and natural materials, the Hampstead-based English avant-garde was distinctly less expressive of a modern urban culture than its predecessor, Vorticism. As sculptors, Hepworth and Moore, for example, were both devoted to the idea of 'truth to materials', which celebrated the influence of materials on working process and recognised their importance to the finished work. A well-established modernist practice, 'truth to materials' also became associated with English craft traditions such as pottery. During the inter-war years such traditions were revived both as models for contemporary art and as potent signifiers of English national identity. Chris Stephens has suggested that Nicholson may have coded the white reliefs with references to English craft traditions to counter their appearance as too foreign and extreme. But – like his friend Herbert Read, rising critic and advocate of the modern movement – Nicholson also genuinely believed that in order to be 'vital' contemporary art needed to have 'grass roots' in an indigenous culture.[6]

Far from representing an anomaly in Nicholson's career, the white reliefs were part of an ongoing project. In these works Nicholson aimed to produce an equivalent of reality itself, as opposed to revealing an abstract 'significant form' in something seen. This desire, which he variously expressed as the pursuit of a universal 'right', 'constructive' or 'poetic idea', informed his work from the 1920s. More pointedly, the reliefs may have been his attempt to resolve an underlying conflict within the modern movement during the first part of the twentieth century concerning the purpose of abstract art: was it the means of improving the man-made environment through design, or the expression of a universal language of spiritual truth? Tastefully and substantially constructed, yet appealing to a higher sense of reality, the white reliefs were perhaps intended to unify these apparently oppositional aims.

Ben made his first relief (fig.33) in Winifred's Paris apartment in December

31
1935 (white relief) 1935
Oil on carved board
101.6 × 166.4

Tate

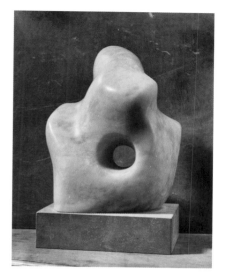

1933. His anecdotal account of the event describes an intuitive artist practising 'truth to materials': 'The first relief came about by accident, when incising a piece of board with some kind of plaster preparation a piece came out where two lines crossed. I then developed this lower level further – I suppose the point is that I was ready for this accident at that moment'.[7]

Whether deliberate or not, there are various reasons why Nicholson might have taken to carving at this time, the most important being his relationship with Hepworth and the availability of her tools.[8] For example, he had enjoyed making linocut prints since the mid-1920s, but now, no doubt encouraged by Hepworth's example, he began to apply lino-block carving techniques to some of his paintings. This can be seen in such works as *1933 (study for a head)* (fig.34), which shares stylistic characteristics with a series of linocut heads he made in the same year. Hepworth's distinctive profile is given definition by the juxtaposition of light and dark typically produced by linocuts. Moreover, as if carving a block, the artist has vigorously scraped back a layer of black paint to expose the coarse grain of the canvas support. The chisel-like marks depicting the eyes also resemble those produced by cutting into lino.

Other influences close to home included his friend the writer and psychologist Adrian Stokes. In the 1930s Stokes wrote extensively about Italian Renaissance art, particularly carving and sculpture. For example, his book *The Stones of Rimini* (1934), for which Ben designed a striking dust jacket comprising two circles in December 1933, celebrated the use of white stone and the important role of light in the animation of low-relief carving. For Stokes, the values of carving – its ability to define space – provided the way ahead for art.[9]

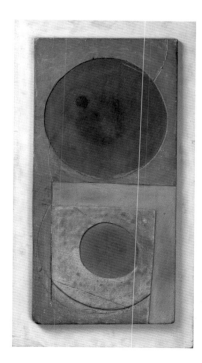

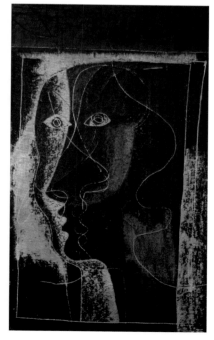

Initially Nicholson's reliefs were roughly made, their irregular shapes in tune with Hepworth and Moore's preference for natural forms (see fig.36). By February 1934 his oatmeal palette of muted brown, grey and cream had given way to startling white. Rather than simply coating the surface, he applied numerous layers of paint, vigorously rubbing down between each layer, using razor blades as part of this process of attrition. His aim was to produce colour which 'runs right through the material and comes out the other side'.[10] Thus integrated, he hoped that form and colour might give a sense of space, and of the work as a real object. Possibly in response to visiting Mondrian's studio in April 1934, he also began using a compass and ruler to clarify his forms, juxtaposing squares and circles using the proportions of the Golden Section, which he established by calculation or rule of thumb.[11]

35
Jean Arp
Constellation According to the Laws of Chance c.1930
Painted wood relief
54.9 × 69.8
Tate

In one sense the white reliefs can be understood as the outcome of Nicholson's intense, ongoing dialogue with Cubism. The painstaking excavation of layers from a support enabled him quite literally to create spatial relationships, instead of picturing them on a two-dimensional surface, as for example in *1932 (Au Chat Botté)* 1932 (see p.22). The evolution of the white reliefs in the early 1930s was influenced by other aspects of the Parisian avant-garde. For example, Nicholson's language of grids and circles, exemplified in *1933 (painting – milk and plain chocolate)* (fig.38), was stimulated by the work of Miró and Calder, while his incising of a painted support was learned from Braque, who carved into his surfaces with the end of a brush.[12]

Most importantly, in Paris the idea of combining the disciplines of painting and sculpture was being explored by a number of artists: Jean (Hans) Arp and other members of Abstraction-Création such as Antoine Pevsner were already making types of reliefs. However, Nicholson's reliefs were distinctive in that they depended on intuitive carving. Writing to Herbert Read, he acknowledged a debt to Arp, but emphasised his own direct engagement with materials: 'Arp's reliefs come from some almost literary poetic idea & for this reason he could conceive & have someone else carve them out? Mine came about bec. of a passion for working with my hands. It's an exact opposite approach I suppose.'[13] But his insistence on the handmade, intuitive aspect of his work was largely overlooked by English critics.

Reactions to the White Reliefs

At the time of their making the white reliefs were assessed almost entirely in terms of Clive Bell and Roger Fry's French-inspired theory of 'significant form', as exercises in 'pure form', appealing to aesthetic sense alone.[14] In England they were mostly viewed as the product of a foreign ideology, the epitome of continental audacity. The reductive nature of these works was further compounded by their whiteness: it was as if art itself had been distilled or purified. Devoid of colour or image, the emptiness of the reliefs threatened to push painting to the edge of extinction; as one critic opined, it was as if the artist was performing 'the death rites of painting'.[15]

This impression was given weight by Kenneth Clark, then director of the National Gallery, when he criticised the reliefs for their 'fatal defect of purity',

37
1932 (painting) 1932
Oil, pencil and gesso on board
74.6 × 120
Tate

36
1933 (6 circles) 1933
Oil on carved board
114.5 × 56

Private Collection

38

1933 (painting – milk and plain chocolate)
1933
Oil and gesso on board
135 × 82

Private Collection

which had exposed 'the poverty of human invention when forced to spin a web from its own guts'.[16] Clark's attack was prompted by Nicholson's solo exhibition of white reliefs at the Lefevre Gallery in September 1935. Seen in conjunction with the first exclusively abstract Seven and Five exhibition, held at the Zwemmer Gallery in October the same year, the show confirmed critical opinion that abstract art was too self-referential to be relevant to society. Geoffrey Grigson, for example, felt that Nicholson had produced: 'An image of infinity … admirable in technical qualities, in taste, in severe self-expurgation, but too much "art itself", floating and disinfected'. Another critic, writing in the *New English Weekly*, concurred that his was 'a lavatory artform, a clean antiseptic bathroom art'.[17] Moreover, with its origins in revolutionary Russia, geometric or 'constructive' abstraction was regarded as dangerously left-wing.[18]

In an attempt to demystify the reliefs, Herbert Read explained how they had evolved naturally out of Nicholson's working method, which had consistently focused on the surface of a work.[19] Cutting out pieces of a panel's surface at varying levels had enabled the artist to replace colour with 'a counterplay of areas and depths, revealed against light'. For Read the reliefs were thus analogous to architectural façades, the perfect complement to modern architecture. He concluded: 'They need space and light; they cannot have too much light. They are the only kind of paintings that can look the sun in the face. They are the best kind of painting to go with the new architecture … They are integral with light and precision, with economy and cleanliness – with all the virtues of modern sensibility'.[20]

This view was reiterated by Paul Nash in his review of Nicholson's Lefevre exhibition. He argued: 'Surely they are pre-eminently suitable as architectural features in the contemporary room, placed there as pictures or sunk into the wall. Their still design, yet capable of subtle change under the influence of light, their severe lines and simple forms, all sympathise with, and at the same time heighten, the character of the modern theme'.[21] Such interpretations of Nicholson's work by friends and close associates gave credence to the view that the white reliefs were subordinate decorative features designed to complement the gleaming, white interiors of modern homes.

The white reliefs certainly had a relationship to modernist architecture and design. Nicholson had a lifelong interest in architecture. In Paris in the 1920s he had admired Le Corbusier's white-painted concrete buildings, his 'machines for living in', which epitomised architecture's International Style. By the early 1930s the 'white style' was becoming visible in England, practised by such architects as Wells Coates and Colin Lucas.[22] Nicholson felt that such modern interiors could provide the ideal environment for his reliefs. When in the summer of 1934 Stokes moved into a studio in the Lawn Road flats designed by Wells Coates, Ben wrote to Winifred: '… the clarity of thought there is quite miraculous – so clean & fresh & clear – (& my small reliefs that he has have a perfect setting …)'.[23]

Since the 1920s the Bauhaus in Germany had espoused a practical collaboration between art, design and architecture to realise a utopian vision in which all the arts were integrated. Geometric abstraction was held to be the modern idiom most likely to unite art and design. Drawing on his friendship with Walter Gropius, former head of the Bauhaus in Germany, Herbert Read articulated a similar vision in *Art and Industry: The Principles of Industrial Design* (1934), predicting that the school of abstract art, including such artists as Mondrian, Hélion, Nicholson and Gabo, 'will occupy, in the future, a relationship to industrial design very similar to the relationship pure mathematics bears to the practical sciences … they will have an essential place in the aesthetic structure of the machine age'.[24] Such

utopian thinking underpinned the publication of *Circle, An International Survey of Constructive Art* in 1937, edited by Nicholson, Gabo and the architect Leslie Martin.

As we shall see, the white reliefs had a role to play in creating a modern domestic environment. But although marketed as ideal accessories for the contemporary home, they were not conceived as mere decoration. As Jeremy Lewison has pointed out, in contrast to Nash's suggestion that the white reliefs could be sunk into a wall, Nicholson always placed them in grey frames to distinguish them from their background, reinforcing their status as art objects.[25]

English Modernity and the Domestic Theme

Hostility to Nicholson as an arch-exponent of continental modernist style was perhaps inevitable given the political and cultural climate of the early 1930s. Over the decade the political mood was increasingly introspective, signalling a transition from Victorian expansionism towards a 'Little England' mentality. Nationalist thinking permeated the cultural sphere. For example, in a series of articles on the theme 'What is Wrong with Modern Painting', *The Studio* blamed internationalism, arguing that: 'Painters would be better advised to stay at home … Britain is looking for British pictures of British people, of British landscapes … a thoroughgoing nationalism'.[26] Paul Nash decried such reactionary views, but had doubts about whether it was now possible to 'go modern' and still 'be British'.[27] Beyond the confines of the studio and immediate circle of friends, the wider culture was hostile, as Nicholson's artist friend Jean Hélion later recalled: 'In those days, to follow abstraction was like walking a tight-rope in a vacuum'.[28]

Although English artists were attempting to establish an avant-garde along international lines, there was a growing belief that native traditions could also provide models for contemporary art. A key advocate of such thinking was Herbert Read, whose art criticism aimed both to interpret European modernism for an English audience, and nurture an English modernism as a continuation of a vital cultural tradition.[29] During the 1920s and 1930s Read contributed to a reappraisal of pre-industrial, English traditions – which had begun in earnest with the Arts and Crafts movement in the late nineteenth century – writing enthusiastically, for example, about pottery, stained glass and the abstract qualities of England's Celtic inheritance.[30]

In the 1930s and 1940s the challenge for English artists was to produce art that was commensurate with a national culture, yet untarnished by totalitarian overtones. Read argued that the English ideal – unlike the 'intolerant extremes' of totalitarian ideologies – was unique in its capacity to transcend nationality. After the war in *The Grass Roots of Art* he spoke out against movements that imposed doctrinaire conceptions on their members: 'I am afraid of the internationalising tendencies of our age – of anonymous powers which would obliterate frontiers, expedite communications, standardise living. I am in favour of all that makes for diversity, variety, the reciprocity of individual units'.[31]

Nicholson embraced the idea of an international community of artists, but his understanding of international modernism similarly depended on the idea of discrete national sensibilities. He despised the overt nationalism associated with the English Neo-romantic movement of the 1930s and 1940s. But his reliance on intuition rather than intellect was perhaps an attempt to define his work against the perceived sophistication of French art. Likewise, his insistence on instinct countered accusations of being too programmatic, that is to say, too German. Moreover, it was his ambition to make a uniquely English contribution to international modernism. In a letter to his friend Jim Ede, probably of 1937 – the height

1934 (white relief –
circle and square) 1934
Oil on carved board
34.9 × 61

Private Collection

of his promotion of the 'constructive' idea in England – Nicholson wrote: 'It always seems to me that to be English in the local sense is what 9/10's, 9¾/10's of English painting has always been – but to be English as the peculiarly English expression of an international, universal movement (life) is completely vital'.[32] An acknowledgement of his cultural 'roots' might also give Nicholson's work the kind of authenticity he recognised in the work of the 'primitive' Celt, Alfred Wallis, and satisfy his critics at home.

Chris Stephens has argued persuasively that the white reliefs may refer to craft traditions that were being revived in England during this period as models for modern art. Though more refined than the earliest painted reliefs, they are surprisingly handcrafted, textured, chiselled and scarred with marks. Furthermore, Nicholson had the works photographed in strong raking light, often from the top right corner (see fig.41) which accentuated, quite dramatically, the different layers carved out of the support. While echoing the concerns of modernist architects, his use of light also exaggerated the liveliness and imperfections of the surface. Far from being pure and mechanical, the reliefs were deliberately displayed as objects carved and weathered by hand.[33]

While Nicholson's reliefs suggest the practice of 'truth to materials', his enthusiasm for the handmade also links his work to such English potters as William Staite Murray and Bernard Leach, leaders of the British Studio Pottery movement in the 1920s, which promoted the merits of traditional handmade as opposed to industrially produced ceramics. Significantly, in his book *English Pottery* (1924) Herbert Read had re-evaluated historically overlooked peasant ceramic traditions. In their direct and simple methods he discovered an exemplary practice for modern artists, proclaiming that as 'plastic art in its most abstract form', pottery illustrated the perfect relationship between material, creative individual and a 'vital' object.[34] In the inter-war years a widely expressed longing for a lost, pre-industrial world led artists in different fields to rediscover folk culture; for example, textile designers Enid Marx and Phyllis and Barron Larcher used peasant and primitive cultures as a source for their designs.[35] Leach's revival of traditional English slipware, and Nicholson's pursuit of primitive simplicity through the handmade, can be seen in the context of this widespread revival of native vernacular culture.

In the 1920s both Read and Leach helped to establish a connection between Englishness and handicraft, which signified the values of a simple, peasant-style domesticity. Leach, for instance, described his work of the 1920s as belonging to 'the kitchen, the cottage, and the country … it only harmonises with the whitewash, oak, iron, leather, and pewter of "Old England"'.[36] Stephens has pointed out that Ben and Winifred consciously adopted rustic-type interior decoration in their Banks Head home, mixing traditional furniture with contemporary art. For Ben and his close associates, modernity represented a new way of life that could dispense with the ills of English society, as Winifred later commented: 'To say that a thing was "Modern" was to say that it was good, sweeping away Victorian, Edwardian, Old Theology, old Tory views. In the New world there would be no slums, no unnecessary palm trees, no false ornament – but clarity, white walls and simplicity – complete and satisfying'.[37] Their sense of modernity expressed itself partly in terms of ideas of an authentic bygone domesticity, in which the handmade played a significant role.[38]

The domestic *mise en scène*, and the integration of his work within it, was always important to Nicholson, as his friend Cyril Reddihough recalled: 'In his home one felt completely free and relaxed and conscious of unobtrusive thoughtfulness on one's behalf. For example, in one's room one would be greeted by a few objects – a new little painting, a book, an interesting bowl, some wild flowers … placed in an arrangement which seemed to double their attractiveness'.[39] Nicholson's work is permeated with references to domestic life and spaces, particularly in the 1920s when he explored such themes alongside other Seven and Five Society artists such as Christopher Wood and Ivon Hitchens.

A predilection for the theme of private, intimate spaces during this period has been linked to the events of the First World War. Following the war there was a widespread reaction against the male-dominated public domain – the world of Victorian and Edwardian masculinity – regarded as culpable for the mass destruction of a generation of young men. Such disillusionment is perhaps echoed in Nicholson's own desire to 'bust up the sophistication' around him, symbolised by his father's stylish elegant interiors comprising Chippendale chairs, Dighton prints and Aubusson carpets.[40]

The texturing of Nicholson's white reliefs – their identity as crafted, handmade objects – possibly identifies them with female labour, and domestic space. As Stephens notes, Nicholson even discussed his own practice in relation to his mother's place within the home, and her predilection for scrubbing the kitchen table.[41] He chose to make one of his larger white reliefs, *1935 (white relief)* from

40
1934 (white relief) 1934
Oil on carved board
55.8 × 80.5
Private Collection

41
1934 (white relief) 1934
Raking light
photograph
As reproduced in *Axis* no.2,
April 1935, p.17

42
1934, October 2 (white relief – triplets) 1934
Oil on carved board
120.5 × 60.5
Private Collection

a mahogany table top. In this instance, his perception of modernity as a way of life – liberated from both the restraints imposed by Edwardian culture and the shadow of his father's achievement – was quite literally expressed in the form of a white relief.

The White Reliefs and Spirituality

Perhaps the most obvious signifier of a spiritual meaning in Ben's work was his use of a lightened palette. Long associated with spiritual truth, light had been a preoccupation in his work since the 1920s, undoubtedly encouraged by Winifred, whose own work explored the properties of colour and light.

During the mid-1920s Nicholson started priming his canvases with white house paint to produce a textured surface over which to paint, incise and rub down. This white coating also imbued his pictures with a certain poetic luminosity. Writing in 1932, H.S. 'Jim' Ede identified the lyrical depiction of light as a principal concern in the artist's work, commenting: 'Like Claude, Ben Nicholson is a master in rendering that changing period of light which lies between night and day, the mysterious moments of dawn, of evening. At such times the human spirit enjoys the experience of intenser life …'.[42] In *1924 (goblet and pears)* (fig.43), acquired by Ede in the mid-1920s, an aura of light seems to emanate from a simple still-life group.

Nicholson's use of white – the signature colour of the modern movement in the 1930s – not only aligned his work with the aesthetic of modern architecture and design, but also with its spiritual aspirations. In his book *Concerning the Spiritual in Art*, Wassily Kandinsky had described white as a 'harmony of silence, which works upon us negatively, like many pauses in music that break temporarily the melody'. As Jeremy Lewison has noted, Nicholson's description of first visiting Mondrian's studio in 1934 strongly evokes Kandinsky's writing: 'The thing I remembered the most was the feeling of light in his room & the pauses and silences during and after he had been talking. The feeling in his studio must have been very like the feeling in one of those hermits' caves where lions used to go and have thorns taken out of their paws'.[43] Though ignorant then of the religious philosophy underpinning Mondrian's work, Ben responded to the 'feeling of light' as a spiritually uplifting experience.[44]

Nicholson's belief in the potential of art to express a spiritual reality dovetailed with modernist concerns. But this conviction was encouraged by Christian Science, which became part of his life in the mid-1920s. In the early 1930s he began to scrutinise the fundamentals of artistic practice, 'to get right back to the beginning and then take one step forward at a time on a firm basis', so that he could produce an object that was not simply a painting or a sculpture but 'a piece of reality'.[45] As Andrew Wilson has pointed out, his concept of pictorial reality involved a spiritual dimension comparable with the Christian Science belief that true reality exists beyond the physical world. Rather than making an abstraction from nature – reducing a motif to pure 'significant forms' – he was attempting to make images of the reality he perceived behind the world of appearances. He wrote 'I think for a painting to be alive one must feel that one cannot touch it. It is thought not paint'.[46]

Sarah Jane Checkland has concluded that the white reliefs are 'icons to Ben's faith', or perhaps 'meditative images of its symbols'.[47] Yet the closest he came to articulating a spiritual meaning for his work was in a response to a questionnaire for the publication accompanying Unit One's exhibition in 1934. Here he drew on the authoritative voice of the pre-eminent mathematician, physicist and

astronomer Sir Arthur Eddington, whose view that recognition of the spiritual reality underlying materiality would reveal the mysteries of the universe concurred with Christian Science beliefs. Nicholson wrote:

I have been asked to answer a great many questions. I would like to quote the following from a speech made by Eddington at Cambridge in 1931:
"Of the intrinsic nature of matter, for instance, Science knows nothing … for all we know matter may itself be mental. … Indeed, not only the laws of Nature, but space and time, and the material universe itself, are constructions of the human mind. … To an altogether unexpected extent the universe we live in is the creation of our minds. The nature of it is outside Scientific investigation. If we are to know anything about that nature it must be through something like religious experience".
'As I see it, painting and religious experience are the same thing, and what we are all searching for is the understanding and realisation of infinity – an idea which is complete, with no beginning, no end, and therefore giving to all things for all time'.[48]

Checkland attributes Ben's general reticence on the subject of his Christian Science beliefs to his private nature, reinforced by the freemasonry tradition within his family. Yet, unlike Winifred or Barbara, he was never entirely wholehearted or consistent in his practice of the religion.[49] However, it seems to have provided a structure for his spiritual inclinations, and a loose philosophical framework for the pursuit of pictorial reality. His abstractions were not intellectual or mystical inventions, but concrete images of the spiritual truth he perceived in the real world. This perhaps explains his statement in *Circle* in 1937 that: '"Realism" has been abandoned in the search for reality: the "principle objective" of abstract art is precisely this reality'.[50] It was important to him that his work was grounded in experience. He later insisted, for example, that his use of the circle originated with a plate on a table, and 'not at all with say any idea of infinity'.[51]

Yet the realisation of an 'idea' was Nicholson's often stated aim. Defending abstraction in 1932, he commented: 'A painting or a carving is quite simply the

expression of an idea. No one can pretend that the early Italians or the negroes, by whom some of the most lovely ideas have been expressed through painting and through carving, tried to "give a faithful picture of natural objects".[52] Such thinking relates to the Christian Science view that mortals evolve images out of thought; it also reflects Roger Fry's explanation – highly influential during the inter-war years – that abstract art should be both an harmonious arrangement and the expression of an artist's idea.[53]

The increased precision of the white reliefs pigeonholed them with the functional aesthetic of the machine age, and the soulless pursuit of formal values. However, for Nicholson, geometric abstraction allowed a more direct communication of his 'idea'. He later recalled:

At first the circles were freely drawn and the structure loose with accidental textures, later I valued more the direct contact that could be obtained by flat planes of colour made and controlled to an exact pitch and the greater tension obtainable by the use of true circles and rectangles – the superficial appeal became less, but the impact of the idea more direct and therefore more powerful. The geometrical forms often used by abstract artists do not indicate, as has been thought, a conscious and intellectual mathematical approach – a square or a circle in art are nothing in themselves and are alive only in the instinctive and inspirational use an artist can make of them in expressing a poetic idea.[54]

By the early 1930s it is clear that Nicholson's expression of an 'idea' involved the entire process of making a work, in which remembered experience played a major role. He later commented that the artist 'will have worked on any form in which he was interested in order to try to realise in this some experience, something not on the surface but as deeply embedded in the material as in himself. This instinctive and unspoilt approach has a natural conviction and is capable of producing something even more actual than the original experience'.[55] This recalls Alfred Wallis's 'primitivism', which in the 1920s had reinforced Nicholson's belief that a painting could be a real object and convey a spiritual feeling. Nicholson particularly admired Wallis's successful combination of memory and experience in the making of an image, using direct and simple means. He later claimed:

About Alfred Wallis: the essential part of his idea was that he worked naturally like the first man will have worked, using the materials to hand (a cave or a cardboard) in order to make an experience. To Wallis his paintings were never 'paintings' but *actual events*. I like to think that … my reliefs are, when they succeed, not a 'picture' but a mental experience.[56]

Underpinning the white reliefs, and all of Nicholson's endeavour, was a belief that art should be more real than life itself, that it should attempt to embody a spiritual reality that lies behind the world of appearances. Such reality was to be found in memory and experience, rather in a literal translation of the world as visually perceived.[57] Writing in the 1960s, Nicholson emphasised the tenacity with which he pursued an idea during the process of making a work: 'If your idea becomes even fractionally separated from your material it becomes decorative and loses its reality'.[58] Thus although the artist painstakingly worked the reliefs, as Wilson has suggested, 'truth to materials' was ultimately subordinate to the realisation of his idea.[59] This position partly explains Nicholson's ability to switch with ease between the apparently opposing styles of abstraction and representation, an ability which worked to his advantage in subsequent decades.

3
St Ives
Abstraction versus
Realism in the 1950s

Arriving in Cornwall with his wife and young family on the eve of war in 1939, Nicholson was in his mid-forties and establishing a profile in both Europe and America. The move to Cornwall marked a dramatic change in their circumstances. Isolated and virtually unable to work or make a living, life became a matter of survival. The reality of war brought hardship and disenchantment, as Nicholson wrote to Margaret Gardiner while he was serving in the Home Guard:

I know how completely disillusioned one feels with all these terrible things happening & with a vista of them continuing to happen afterwards in peacetime ... So many times in the last 2 years I have felt near breaking point ... There is at best this, that all the badness in humanity *is coming to the surface* & can be tackled openly – I had no idea such things existed – I suppose one just shuts one's eyes to it.[1]

Yet he lost none of his desire to work. In the face of the restrictions imposed by war he managed to keep his practice going by experimenting on a small scale in various styles – abstract reliefs, flat colour abstract paintings, table-top still-lifes, landscapes – all of which were informed by his drawing. He also began to merge different genres, for example, combining landscape and still-life, a practice that he would fully exploit in the post-war period.

Despite difficulty and obscurity, after the war Nicholson was rediscovered as Britain's pioneer practitioner of abstract art in Britain. The key to his success lay in the sheer ambition of his work during the late 1940s and 1950s, and the apparent ease with which he combined abstraction and naturalism in his work. He was also adept at self-promotion. Identified as a 'gang-leader' of the pre-war English avant-garde, with Hepworth and Gabo (who lived in Cornwall between 1940 and 1946) he helped to establish St Ives as a centre for avant-garde art during the 1950s.

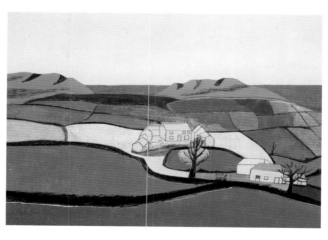

44
1940 (Cornish landscape) 1940
Oil, tempera and pencil on board
25.4 × 35.5
Bolton Museums and Art Gallery

Although he spent time absorbing the landscapes of Ticino, Cumbria, Yorkshire, Brittany, Italy and Greece, Nicholson lived in Cornwall for almost two decades, and its effect on him was considerable. Later, based in Switzerland, he wrote to Herbert Read that, although he had been happy in Hampstead, he had been happiest in Cornwall, where land and seascape had so permeated his existence that he felt his roots were there.[2] This account of Nicholson and his relationship with St Ives focuses on how he reintroduced representation or 'naturalism' into his work, culminating in the grand table-top still-life paintings of the 1950s, and assesses the significance of these works in the context of the heated debate between abstraction and realism which took place in British art during the 1950s.

The Impact of Cornwall

Nicholson had become familiar with Cornwall's rugged natural beauty in the 1920s, but during wartime its impact was all the more poignant. Writing to Paul Nash shortly after his evacuation to Penwith, he commented:

The country here is very lovely & it's so many years since I lived in the country and with all these majestic mines and dictators left & right one never knows if each marvellous thing one sees may not be the last time one sees it and so it becomes very intense – I used to have one or two dreams recurring annually about the sea – I always thought the stories were overdone & the drama & terrific intense colour – but the real thing has been *much more so*.[3]

With the market for abstract art non-existent, Nicholson was under pressure to make commercially attractive landscape pictures. He set about producing landscapes based on the 'George and Rufus' illustrations he had begun for an imaginary children's story in 1938 (see fig.44). Describing his landscapes as 'Cornish best-selling schemes', he made it known that they were not as important as his other work.[4] He proved this by remaining a vocal advocate of the 'constructive idea'. For example, in a statement 'Notes on Abstract Art' published in *Horizon*, October 1941, he defended the relevance of abstract art in wartime: 'I have not yet seen it pointed our that this liberation of form and colour is closely linked with all other liberations one hears about. I think it ought, perhaps to come into one of our lists of war-aims'.[5]

Yet the Cornish landscape had a profound effect upon him. The peculiarities of St Ives and its environs – the sea-dominated horizon, hillsides and rooftop sky-

45
1941 (painted relief – version 1) 1941
Oil on carved board
66 × 140.3
Private Collection

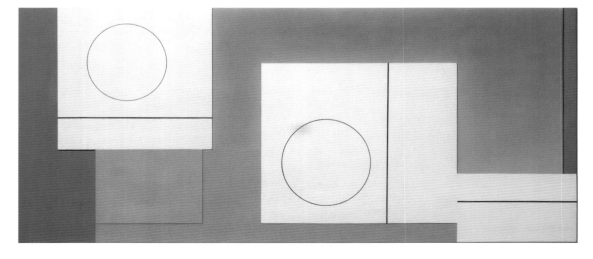

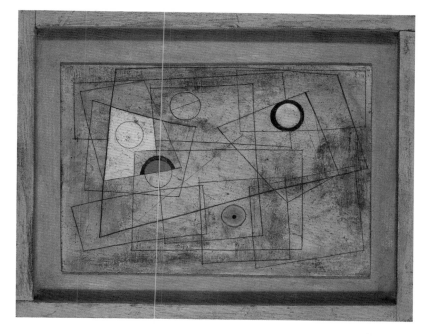

line – entered his visual repertoire. Landscape and nature also began to affect his abstract paintings and reliefs, prompting a new sense of colour and texture, as, for example, in *1941 (painted relief) version 1* (fig.45). The brightness of his silvery blues resembles Cornish light, while his use of greens evokes the landscape. He also relinquished the right angle allowing a new freedom in his use of line, as seen in *1945 (parrot's eye)* (fig.46), which shows a fresh spontaneity.

After the war Nicholson set about re-aligning his practice to the international modern movement, which for him meant a re-evaluation of such pre-war giants as Braque, who had been so important to him in the 1930s. In 1949 he secured tenancy from the Arts Council of a large purpose-built studio off Porthmeor Beach in St Ives, which enabled him to work on an unprecedented scale. Writer David Lewis, living in St Ives at the time, recalled: 'You couldn't see the ocean from his studio, but you could hear its ceaseless rhythms, even on calm days, and through the skylights came the reflected light of sea and sky'.[6] Here he reworked Cubist themes in a series of large, complex still-life paintings, based on the jug, mug and bottle motifs that recur throughout his oeuvre. An early example, *December 5, 1949 (poisonous yellow)* (fig.23), marked the extension of his palette to include pungent, acid colours.

Although he continued to make reliefs and drawings, the intricate still-lifes, synthesising foreground and background, volume and space, dominated his output for almost a decade. Typically, his still-lifes comprised semi-abstract objects drawn in outline as a series of rhythmic, overlapping shapes composed on a table top. A precedent can be seen in the severely rubbed back pre-war painting *1931–6 (still-life – Greek landscape)*, featuring a still-life group of interconnected objects. In 1954 he wrote to Patrick Heron:

In dealing with space I like a series of flat planes which interchange their position in depth … I suppose the recent linear development is using a free movement to develop relationships in depth – but always I hope in depth & never on the single plane of the surface. One does not live on a single plane & so there is no reality in a single plane in a ptg.[7]

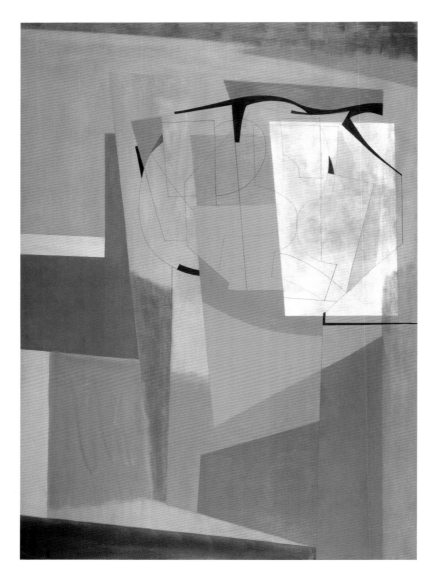

47
June 4–52 (tableform)
1952
Oil and pencil on
canvas
158.7 × 113.7

Albright-Knox Art Gallery,
Buffalo, New York

48
Georges Braque
Studio II (Atelier II)
1949
Oil on canvas
131 × 162.5

Düsseldorf,
Kunstsammlungen NRW

49
*November 11–47
(Mousehole)* 1947
Oil and pencil on
canvas mounted on
board
465.5 × 58.5
The British Council

Although derived from an understanding of pre-war synthetic Cubism, Nicholson achieved his own interpretation. As Jeremy Lewison has observed, Nicholson's 'disciplined line carved open the picture space, which he filled with light and colour based on his perception of the environment'.[8] *June 4–52 (tableform)* (fig.47), for example, glows with the colour and luminosity of the Cornish coast. While Braque's grand still-lifes were located indoors, Nicholson's invariably referred in some way to the world beyond the studio. This is most obvious in *November 11–47 (Mousehole)* (fig.49), in which a flattened post-Cubist still-life appears on the quayside of a Cornish harbour, the incongruent elements united only by colour and painterly facture. In *July 22–47 (still life – Odyssey 1)* (fig.50), ostensibly an abstract still-life configuration, a landscape background is more subtly evoked by a wavering, horizontal pencil line at the top of the painting.

In a number of vertical still-life compositions, such as the modestly sized 1953 *Feb 28–53 (vertical seconds)* (fig.52) and the large-scale *1953 February (contrapuntal)*, Nicholson dispensed with any tangible reference to landscape space, preferring to allude to nature – white light, blue sky, yellow sand, muddy green earth – through placement of patches of colour. He spoke of the relationship between the still lifes and nature, commenting, for example: 'All the "still-lifes" are in fact land-sea-sky-scapes to me'.[9] In later works his use of colour responded to the light and landscape of Italy, which he visited in the 1950s. In the last of his

50
July 22–47 (still life-Odyssey 1) 1947
Oil on canvas
69 × 56
The British Council

51 BELOW
1959 (Argolis) 1959
Oil and pencil on masonite
122 × 230
Private Collection

52 OPPOSITE
Feb 28–53 (vertical seconds) 1953
Oil on canvas
75.6 × 41.9
Tate

53 OVERLEAF
August 1956 (Val d'Orcia) 1956
Oil, gesso and pencil on board
122 × 213.5 × 3
Tate

majestic still lifes, *1959 (Argolis)* (fig.51), made in Switzerland, sea and sky flood the table top to become part of the interior space.

The theme of the laden table is a tradition in European painting, and Nicholson's table-scapes evidently relate to the grand still lifes of such modern masters as Cézanne, Picasso and Braque. In the Cubist works of the latter, the laden table became a metaphor for a human being. While this might also be true of Nicholson's vertical format table tops, his horizontal still lifes such as *August 1956 (Val d'Orcia)* (fig.53) are more evocative of Europe's historical architectural skylines, which Ben had been drawing on his post-war travels.[10]

A human presence, however, might be detected in all of the still-life paintings through the rapid movement of the artist's pencil line. Nicholson, a lifetime enthusiast of ball games, was fascinated by the grace of the human body in action. The dynamism and complexity of his lines perhaps reflect movement of the body in space. As John Russell has remarked, 'something of his own spring-heeled tread and quick impulsive movement comes across in the work

… Doorways are judged, in Nicholson's work, by the way a man would look when he walked through them; and hillsides by the way in which he would get to the top of them'.[11] Interestingly, Nicholson was one of the first artists to respond with enthusiasm to American Action painting, highlighted by the Tate Gallery's 'Modern Art in the United States' exhibition in 1956, which he felt was a 'healthy, free painting development'.[12]

Although landscape remained a subsidiary subject in his oeuvre, the influence of nature pervaded his work, enabling him to convey a sense of connection with the physical world. In a statement of 1957 he commented: 'However non-figurative a painting may appear to be it has its source in nature'.[13] Importantly, with the still-lifes of the 1950s he had established a middle ground between abstraction and realism that would secure his reputation abroad, and inspire a younger generation of artists at home.

Abstraction versus Realism

The mid-1950s marked a highpoint in Ben's international reputation, but although praised in the *News Chronicle* just after the war as 'our own British Picasso', acceptance at home during the post-war years was hard won.[14] After the white reliefs, it took more than twenty years for abstract painting to win credibility in Britain. During the 1940s Neo-romanticism and social realism dominated British art, both of which were considered more relevant and accessible than abstraction. However, the development of *tachisme* in post-war Paris, and the emergence of a group of young 'constructivist' artists, with whom erstwhile realist painter Victor Pasmore became associated, indicated that abstraction was being resurrected as a significant idiom.[15]

Yet the British remained suspicious. Mistrust and incomprehension were com-

pounded by an ongoing confusion about the definition of abstraction. On the one hand it was regarded as pure form abstracted from nature. This view was held by Herbert Read, for whom 'vital' abstract art was the kind that responded to the structures of the universe governing organic growth: 'Attuned to these rhythms and proportions, the abstract artist can create microcosms which reflect the macrocosm'.[16] But abstraction was also perceived as an art devoid of any external reference. This latter position, which described a constructivist approach, was articulated in 1951 by Laurence Alloway in *Broadsheet No.1 Devoted to Abstract Art*:

What is generally termed abstract is not to be confused with the abstraction from nature which is concerned with the visual aspect of nature and its reduction and distortion to a pictorial form … abstract art has … become a construction or concretion coming from within. The abstract painting is the result of a creative process absolutely the opposite to abstraction.[17]

After the war the term 'abstract' was vilified by both left and right as either capitalist or communist.[18] For many it remained exclusive, sectarian and cultish. While abstraction was readily identified as an international style, the strong impulse to identify a national tradition during the post-war period led most critics to favour a kind of urban realism depicting the ordinary and everyday. Between 1951 and 1953 the critical debate between abstraction and realism was publicly aired in a series of exchanges between Patrick Heron and John Berger in the pages of the *New Statesman and Nation* and the *Listener*. Through their debate realism emerged as a committed art of the left, whereas abstraction represented the freedom of artists to work unconstrained by ideology. By the end of the decade, the notion of individual creativity expressed by abstraction won the upper hand.

During the period of critical conflict, however, Nicholson – the high priest of British abstract art – was singled out for particular criticism. In 1955, following his successful showing at the Venice Biennale in 1954, which toured to other venues including the Tate Gallery, Berger argued that devoid of subject, his work had nothing to communicate: 'The abstract *easel painter* is now an anachronism, for he must either remain always dumb about the world or alter his language fundamentally. Nicholson has felt too much to remain pure and dumb all the time, but hasn't the means to say anything of consequence'.[19]

In 1956 John Rothenstein, director of the Tate Gallery, published a damning – and widely circulated – assessment of Nicholson's work in his second volume of *Modern British Painters*, which voiced mainstream scepticism about abstraction. Dismissive of the view that abstract art could somehow give material form to the reality underlying appearances, Rothenstein argued that the value of abstract art, if any, lay in 'straightforward visual satisfactions, rooted indeed in humanity but with no mystical or cosmic overtones. You will look in vain for metaphysical revelations of the structure of reality from Ben Nicholson'. He concluded: 'Ben Nicholson is not an innovator, still less a revolutionary, but the most accomplished living practitioner of a new academicism. A movement so shallow in its underlying philosophy is unlikely to have a long life, but the best of Nicholson's works will surely survive the ebb of the abstract tide'.[20]

Despite such views, efforts were made by certain critics to establish an aesthetic common ground between abstraction and realism. Before the outbreak of war it seemed possible that London might become the centre of the European avant-garde. In the post-war decade, although many émigrés had long since abandoned London for America, the cultural field still seemed wide open. There was a concerted effort on the part of a new generation of critics and artists,

including David Sylvester and Patrick Heron, to argue the case for a School of London to replace the pre-war supremacy of the Ecole de Paris. As the extent of Nazi atrocities emerged at the end of the war, humanism and liberalism became increasingly important as therapeutic ideologies. In the cultural sphere, a similar rejection of extremism found expression in a desire to establish a central position between the apparently polarised idioms of abstraction and realism.

Although Patrick Heron promoted a School of London that included Nicholson, Hepworth, Moore and artists in St Ives, he was wary of constructive abstraction, which denied the possibility of a subject. In the early 1950s he argued that the future of modern painting lay in the strengthening of 'the middle way between pure abstraction and object representation', not in the new 'academicism of mechanical abstraction'.[21] Denouncing purely abstract art as artistic 'heresy', Heron believed that British artists could build on the 'lyrical synthesis' of abstraction and realism found in the work of masters of the Ecole de Paris, Braque and Bonnard. For him, Bonnard in particular came to represent 'the central tradition', in which the tendency towards abstraction was moderated by the impulse to communicate a subject.[22]

In the context of such heated discussion about the future of art, and continued doubt about the validity of abstraction, Nicholson held fast the concept that had nourished his work since the 1920s, namely, the primacy of the artist's idea. In the catalogue accompanying his Tate retrospective, he stressed the importance of focusing not on whether a work represented something or not, but on the artist's idea:

How can one paint, as John Wells had remarked, the noise of a beetle crawling across a rock? The poetic experience of such an event can only be realized in a painting by an equivalent, out of the painter's total experience, when it can become all things to all men, all beetles to all rocks. … 'Cubism' once discovered could not be undiscovered and so far from being that 'passing phase' so longed for by reactionaries it (and all that its discovery implied) has been absorbed into human experience as we know it today.[23]

Of all the commentators on Nicholson's work Read was the most influential and long-serving. In the 1930s, living among what he later described as Hampstead's 'gentle nest of artists', he devised a theoretical framework for understanding modern art that would accommodate the oppositional strains of contemporary avant-garde practice, namely abstraction and surrealism.[24] By the mid-1930s he considered them as equally valid though entirely opposite art forms. After the war, realising that the English avant-garde did not entirely fit his dialectical model, he modified his approach.[25]

With the publication of Nicholson's first monograph by Lund Humphries in 1948, Read was given the ideal platform for clarifying his view of abstract art.[26] In his introduction he explained abstraction in Wilhelm Worringer's terms as the expression of a psychological tendency.[27] For Read this explained the ease with which Nicholson switched between abstraction and naturalism in his work: 'In certain cases it seems possible for an individual to alternate between the extremes represented by this polarity – to tend in one psychological phase towards an affirmation of the world which results in a naturalistic style, and in another psychological phase towards a rejection of that world, which results in an abstract style of art.'[28] Although acknowledging that as an artist Nicholson 'always moors his sensibility to a geometrical pier', Read justified the apparent contradiction in the artist's plurality of styles as a peculiar sensibility expressed with different visual 'resonance'.[29]

Nicholson approved of this interpretation, and described his own feelings

55
December 1955 (night façade) 1955
Oil on board
108 × 116.2

Solomon R. Guggenheim
Museum, New York

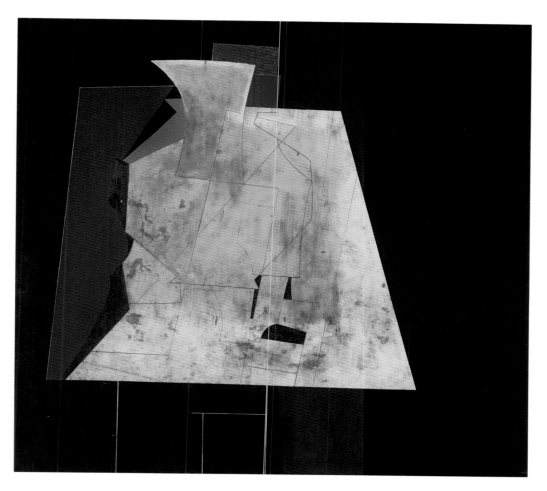

about abstraction and representation in a statement in the second edition of the monograph published in 1955: 'The kind of painting which I find exciting is not necessarily representational or non-representational, but it is both musical and architectural, where the architectural construction is used to express a "musical" relationship between form, tone and colour and whether this visual, "musical" relationship is slightly more or slightly less abstract is for me beside the point'.[30] Such thinking might well have found expression in a work such as *December 1955 (night façade)* (fig.55), a semi-abstract, architectural still-life group, with its contrasts of light and dark, line and blocks of solid colour.

In the face of chaos caused by war and its aftermath, he became increasingly committed to producing work that had a quiet, timeless quality, as he wrote in 1954 to Lillian Somerville, director of the Fine Arts department at the British Council:

What I am interested in in painting is in realising an experience and not at all in 'making a painting'. It's to do with creating an enduring reality based on rhythm arrived at by means of all the senses. In my work I don't want to achieve a dramatic arresting experience exciting as that can be but something – more enduring – the kind of thing one finds say in the finest Chinese vases or in the Cézanne apple paintings.[31]

As far as foreign critics were concerned he achieved this in the grand table-top still-lifes, which represented a return to the level of ambition seen in his pre-war

work. Although universally criticised at home, Nicholson's fusion of naturalism and abstraction brought post-war success abroad. Reviewing his exhibition at the Phillips Gallery on 15 April 1951, the critic of the *Washington Post* commented: 'One of the most individual and elusive of contemporary artists, his work evades description, for it is based on elements of naturalism and cubism, a combination of the real and the unreal, of geometric discipline in part, of free imaginative drawing and painting in part'.

During a period of transition, when opinion was divided about whether the rightful home of the avant-garde was Paris or its up and coming rival, New York, Nicholson's mature work may well have exemplified an international style acceptable to all sides.[32] His restrained style, which held abstraction and realism in balance, was considered calming and restorative, safe rather than radical. Following the tumultuous experience of war, his works were admired for holding the extremes of classical perfection and romantic intensity of feeling in check. As Belgian critic Robert Geerts proclaimed: 'The power of his style and the serenity of the spirit which inspires him are of such a quality that one can, without fear of being ridiculous, regard him as the J.S. Bach of abstract painting'. Furthermore, while emerging out of Cubism and related to the work of Mondrian, the 'delicate lyricism' of Nicholson's 'discreet' work was identified as personal and culturally specific, the expression of an English sensibility, echoing a tradition established by Gainsborough, Constable, Bonington and Turner.[33]

'Father' of the St Ives School

The presence of Nicholson, Hepworth and Gabo in St Ives had a huge impact on a younger generation of artists. On arrival they managed to interest a number of artists – for instance, Peter Lanyon, Margaret Mellis and John Wells – in the constructive idea. However, a coherent group practice never developed, perhaps because Gabo, the most theoretical, left Cornwall in November 1946.[34] Although both Nicholson and Hepworth continued to promote the virtues of abstraction, during the 1940s they were increasingly keen to disassociate themselves publicly from Contructivism, the Russian modernist art movement. Nicholson consistently used the term 'constructive idea' to represent an attitude to life rather than an aesthetic dogma.

In September 1946, Wells, Lanyon, Bryan Wynter, Sven Berlin and Guido Morris held their first exhibition as the Crypt Group, through which they began to moderate constructive abstraction with an interest in the phenomenological world. In February 1949 Nicholson and Hepworth reasserted their influence through the instigation of the Penwith Society of Artists in Cornwall as a platform for the development of 'advanced' art. The society was formed when a number of rebellious modern and liberal traditionalists defected from the established St Ives Society of Artists, with Nicholson and Hepworth apparently engineering the revolt. Nicholson described the incident as a 'loud BANG', and although he regretted 'that so many extremely nice people are bad artists as well as friends of ours', as in his handling of the Seven and Five Society, commitment to promoting avant-garde art took precedence over personal feelings.[35]

Significantly, they invited Herbert Read to become the President of the fledgling society. By the late 1940s, Read had become part of the new left-wing establishment largely through his influential position on the British Council's Art Advisory Committee, and was becoming a figure of international repute through his books and lectures. But things did not run smoothly. Fears that Nicholson and Hepworth would dominate the organisation were soon realised when she

*October 20 1951
(St Ives harbour from
Trezion)* 1951
Oil and pencil on
board
45·5 × 52

Private Collection

proposed – with his backing – what quickly became known as the 'ABC' rule, which required artists to categorise their work as traditional/figurative and modern/abstract. The rule smacked of intolerance, failing to take into account that several artists were practising a 'perceptual abstraction', combining abstraction and realism. Ironically, much of Nicholson's work also fell into the 'B' category. The instigation of the rule proved divisive, and by the end of 1950, founder members such as Berlin, Morris and even Peter Lanyon, who had initially helped Nicholson and Hepworth propose the rule, had resigned.

Yet despite such rivalries, Nicholson and Hepworth inspired younger artists to achieve a new level of professionalism and internationalism in their work. Contrary to the view that he was overly protective of his own practice, Nicholson also offered critique and advice. Wilhelmina Barns-Graham, who had a space at Porthmeor Studios, recalled: 'Ben was often generous in what he said about his method of work ... I was frequently asked to his studio and he generously came to mine'.[36] Although younger artists were engaged with developments taking place in painting in Europe and America during the 1950s, it was arguably Nicholson's early example that nurtured an attitude of seriousness and ambition, and exposed them to influential contacts in the metropolitan art world.[37]

The love-hate relationship many artists experienced with Nicholson is perhaps best illustrated by Patrick Heron's response to his work. Although Heron held Nicholson in high regard and defended his work in print, in the process of defining his own goals he was also critical of the senior artist. For example, Heron decried the lack of 'pictorial ingredients' in Nicholson's most 'constructivist' work, and queried his interpretation of Cubism. He wrote, 'If Picasso and Braque portray a real object – and the result is a Cubist mug – Nicholson portrays a Cubist mug – and the result is, therefore, at two removes from reality'.[38] He also took particular issue with the Nicholsons' treatment of space.[39]

Yet Heron admired Nicholson's still-life paintings, which for him successfully evoked the atmosphere and light of the Cornish landscape:

I believe Ben Nicholson likes to insist upon a connection between the landscape in which he lives (St Ives, Cornwall) and his painting. The connection is there, and is a strong one; but it is oblique. When Nicholson attacks landscape direct, giving us a view of St. Ives harbour over the roofs and chimneys of the town, he is possibly too picturesque … Such landscapes are post-cards pinned on the wall behind the Nicholson still-life group.
On the other hand, the still-life paintings are impregnated with qualities of light, texture and colour which convey one at once to St Ives. The over-clean 'washedness' of the cool colours and the smooth neat textures are qualities very precisely related to that rain-washed, Atlantic-blown town. And the multiplicity of pale greys, off-whites, pale blues, purples and yellows all have a valid basis in the white ocean-reflected light which almost bleaches things in its diffuse radiation.[40]

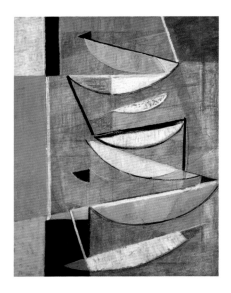

Nicholson's development of a modern style of painting that was both abstract yet at the same time diffused in some way with reference to the natural world was undoubtedly important for such artists as Lanyon, Heron, Roger Hilton and Terry Frost, all of whom became identified with a school of modern painting in St Ives. As Margaret Garlake has suggested, while for Nicholson the table-top still lifes represented a return to pre-war business, for artists in St Ives they may well have demonstrated the successful reconcilement between a modernist idiom and 'appearance painting' that became key in defining the art of the St Ives school.[41]

Barbara Hepworth became undisputed queen of St Ives, remaining there until her death in 1975. Her association with the town is fixed in perpetuity by the preservation of her studio as a museum. There is no such memorial to Ben Nicholson – probably he would have hated one. Shortly after his marriage to Felicitas Vogler he left St Ives for Switzerland in 1958, by which time his achievements were finally being recognised at home. Thanks in no small part to his influence, the remote artist's colony was also becoming established internationally as the centre of Britain's official avant-garde.

57
Terry Frost
Green, Black and White Movement 1951
Oil on canvas
109.2 × 85.1

Tate

58
Ben Nicholson in
St Ives, *c*.1955

Tate Gallery Archive

4
A Kind of Beauty
Nicholson's Aesthetic Style

Although Nicholson was responsive to the work of other artists, from Piero della Francesca to Braque, Alfred Wallis to Mondrian, throughout his career he made images that were distinctly his. There is a consensus critical view that his work, in whatever medium or genre, exudes a distinctive aesthetic sensibility, or taste – and this has been a source of both praise and contempt. As a detractor of his work in the 1950s, John Rothenstein suggested that neither William Nicholson nor his son 'belongs in any radical sense to the race of pioneers; each accepted a mode of expression current in his day, and each used his dexterity, his pertinacity, but above all an almost impeccable taste, to bring it to a dandyish perfection'.[1]

This critique has persisted since Nicholson's death in 1982, and was clearly expressed in responses to the Tate Gallery's major retrospective exhibition of his work in 1993. Although acknowledging the white reliefs and abstract paintings of the 1930s as 'among the most remarkable English works of art this century', critic Andrew Graham Dixon focused on what he perceived as the negative effect of Nicholson's inherited 'nonchalant facility' and 'cautious tastefulness', which he saw as working against the artist's modernist intentions. Of *1928 Porthmeor Beach, St Ives* (fig.14), for instance, Graham Dixon wrote: 'The attention paid to pictorial harmonies of off-white and ochre marks Nicholson out as something of an old-fashioned Whistlerian aesthete. The result is a kind of nice dirtiness: the equivalent, in painting, of Marie-Antoinette dressing up as a shepherdess'.[2] Even one of Nicholson's greatest champions over the last forty years, Charles Harrison, has felt compelled to comment on Nicholson's tendency to indulge in 'tasteful decoration'.[3]

There are various ways in which Nicholson's sense of taste might be defined – through his use of colour, composition and line, for example. But perhaps more important than all of these is the surface of his works, with which he remained obsessed throughout his working life. Arguably, the treatment of his surfaces, particularly through a process of weathering or texturing, is what gives his work the Nicholson signature. This pared-down aesthetic, developed as a riposte to his father's slick, luxuriant paint, produced a kind of beauty, albeit one of imperfection rather than excess. As Peter Khoroche has recently noted,

The beauty of imperfection – of the worn, torn, scuffed or abraded surface – is central to Nicholson's aesthetic and offsets the clear perfection of his line. Sometimes an imperfection can be the starting-point of a work. Accidents such as blots, tears or discolouration were welcome … If there was no ready-made imperfection, then he would manufacture one … to heighten the object-quality of the work and to bring it closer to something natural.[4]

The Weathered Surface

From an early stage in his career Nicholson was interested in varying the surface of his canvas through a process of application and attrition. In *1921–c.1923 (Cortivallo, Lugano)* (fig.60), for example, areas of the landscape have been rubbed back, probably with a cloth, to leave a transparent film of paint which contrasts with the thick impasto of sky and foreground. Significantly, the vigour of the line drawing of the tree suggests the very physical action of gouging the image into the paint with a pencil.[5]

According to Nicholson, the idea of focusing on the surface of his works was prompted by his brother-in-law, Wilfred Roberts, some time in 1921–2:

I used to prepare various kinds of textures on scraped boards & canvasses & hang the canvasses on nails on the walls of my studio to dry (they had to dry for a long time until bone dry before I could paint on them) – Wilfred came into my studio to look at the latest ptgs & didn't seem to like them much & he said he really preferred the canvasses on the walls – I realised he was right – & then came the problem of how to make these beginnings into something real.[6]

One of the main techniques he employed to this end was texturing a surface with a white primer, a method originating perhaps with Picasso and developed by Braque. For Nicholson it became one of the most important techniques in his pursuit of a naive 'primitivism' in the mid-1920s. In this he was greatly encouraged by Christopher Wood, who introduced him to the process of coating the surface of a canvas with a commercially produced white undercoat such as Ripolin. This enabled the reuse of old canvases, but more importantly it produced a dynamic surface on which to paint, and was particularly effective in enlivening otherwise flat areas of a single colour. Moreover, Wood often incised the paint to reveal the white ground, drawing attention to the status of the painting as an object in its own right. Such unconventional treatment of the surface also suggested something childlike and authentic.

Wood and Nicholson's meeting with the so-called 'primitive' painter Alfred Wallis in St Ives in 1928 affirmed their belief that such techniques could assist in their search for a sincere, 'naive' form of art. Untrained and intuitive, painting on

59
1929 (Holmhead, Cumberland) 1929
Oil and pencil on canvas
50.8 × 76.2
Private Collection

60
1921–c.1923 (Cortivallo, Lugano)
1921–c.1923
Raking light photograph
Tate Conservation

61
Christopher Wood
Dahlias and Larkspur
1930
Oil on board
39.5 × 31.5
Private Collection

whatever was to hand with thick household paint, Wallis represented the 'first creative artist', a primitive capable of making images charged with emotion and raw poetry. The worn, weathered appearance of Nicholson's own pictures connoted a similar artlessness – a lack of concern with polish and painterly accomplishment. It also gave the impression of an object aged over time by natural processes, as noted by Paul Nash in a review of Nicholson and Hepworth's joint

exhibition at the Tooth Gallery in November 1932. In Nash's view, Nicholson's paintings of 'mugs and jugs, mythical fish' and 'deformed musical instruments' had 'all the charm of old walls or pavements stained and scarred, encrusted with exquisite lichens'. Similarly, Hepworth's carved abstractions had the look of 'stone worn by the elements through years of time'.[7]

As mentioned in chapter two, through the concept of 'truth to materials' sculptors such as Hepworth and Moore were keen to emulate the effects of natural, organic processes in their approach to carving. In 1933 Adrian Stokes wrote about Nicholson's paintings in terms of these sculptural aims, neatly summing up the connection between the surface of an object and the passing of time: 'A stone incorporates in its very texture the movement of lapsed centuries as a simple thing'. He also observed that Nicholson relied more than most artists on the 'rich plaster covering' of his canvases and panels, which served 'in the role of the carver's block'.[8]

Even in such urban works as *1932 (Le Quotidien)* (fig.62), a Cubist-inspired still-life comprising mug, cup and newspaper, Ben might be seen to be working away at a surface to evoke natural processes. In this work he began with a smooth, primed surface, which he then distressed by scraping back the paint and scoring it horizontally and vertically with a razor. Applying a sooty-brown black over pale grey, the artist then rubbed it down, forcing the black into the lines and grooves marking the surface. In short, this work shows him using a method of applying paint and removing it between layers to achieve the appearance of transparency and thinness, as if the paint had been gradually eroded to reveal underlying strata.

In the 1940s, the technique of rubbing back a textured surface was appropriated by English Neo-romantic painters to dramatic effect. John Piper, for example, used a distressed surface to convey the faded but defiant grandeur of England's architecture and landscapes under the threat of war. Uninterested in the nostalgic connotations of Neo-romanticism, Nicholson nevertheless continued to use the worn surface, increasingly to convey a universal idea of timelessness. This came to fruition in the late 'primitive' reliefs of the 1960s and 1970s, which refer to the timeless quality of the ancient stones he had encountered in Cornwall and Brittany. Although the late reliefs bear titles that associate them with particular places, ancient monuments or stones, they are not representations but equivalents for the artist's experience of them; not works of art, but – in the artist's words – 'actual events' or a 'mental experience'. In 1968 he commented: 'I've always liked the idea of the sculptor who sits for 10 or 15 years carving a single object on the edge of a primeval forest, not to send to the "Documenta" at Kassel but because he has a passion to make this object, this living thing'.[9]

62
1932 (Le Quotidien)
1932
Oil on board
37·5 × 45·7
Tate

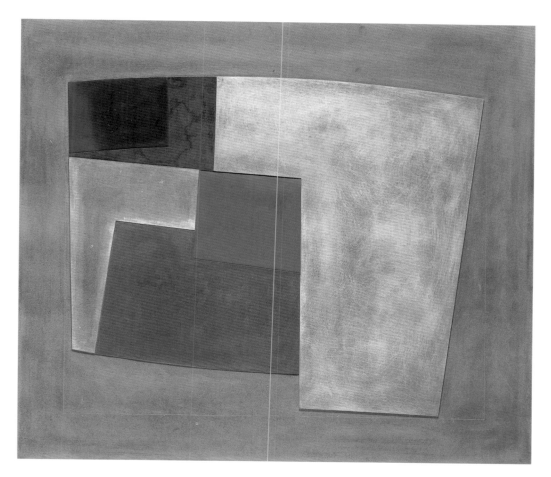

63
1967 (Tuscan relief)
1967
Oil on hardboard on
blockboard
151.8 × 167.6 × 29

Tate

The late reliefs represent the culmination of the pursuit of 'primitivism' in Nicholson's work. Like an 'ur' artist, he dispensed with studio apparatus and began using his whole body to work the surfaces of his reliefs, which were so large he had to place them on the floor. He reportedly commented, 'You can find out a lot about a relief if you crawl over it intelligently'.[10] Such physical engagement linked his practice to that of American 'action' painters, for example Jackson Pollock, who ritualised the physical act of painting by dripping paint over a canvas on the floor.

Nicholson always enjoyed the physical act of making a work, but it became increasingly important to his aim of making something 'vital' or 'alive'. For him the physical relationship between artist and his materials was crucial, playing a key role in the sense of an artwork being an 'event'. This dependency on the process of making, which allowed an element of play or chance and stressed an intuitive approach, remained central to his practice.[11] It is significant that even towards the end of his life, with his monumental, heavily worked reliefs, he continued – unlike Moore and Hepworth – to do all the carving himself.

Scrubbing the Table

As we have seen, techniques of weathering linked Nicholson's work to modernist practice. Yet the laborious working of a surface was also rooted in the formative experience of watching his mother scrub the kitchen table. This particular asso-

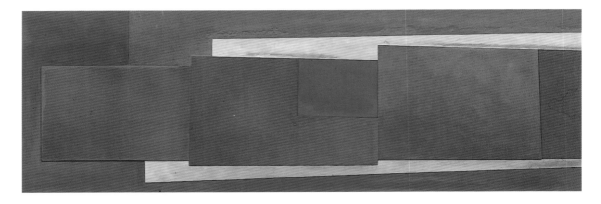

64
1966 (Zennor Quoit 2)
1966
Oil on laminated
masonite panels
118.1 × 264

The Phillips Collection,
Washington, DC

ciation with his mother became the lynchpin of his self-mythology. According to artist Wilhelmina Barns-Graham, who knew him well in St Ives in the 1940s and 1950s, he frequently referred to working on and with surfaces in relation to his mother scrubbing the kitchen table top: 'He had been very impressed with her and must have spent some hours with her watching this – for this picture I have of him & her is vivid'.[12]

Over time, this anecdotal memory of his mother became a potent signifier for Nicholson in relation to his own practice, not least, perhaps, as a way of distancing him from the art and lifestyle of his father. As John Russell has suggested, it gave him the courage to plough his own furrow:

Seeing what passed for art in the world around him, he made up his mind that what his mother had to say was very much to the point. And it wasn't a general idea, or the notion of making a *tabula rasa*: it was simply the act of scrubbing a particular table, one's own, and getting the feel of what one could do with it.[13]

Scrubbing is a useful metaphor, referring both to Nicholson's rigorous, workmanlike approach, and his engagement with materials. But for the artist it may also have had spiritual connotations, signifying his mother's Scottish Puritanism: the relationship between simple domestic labour and the divine is part of the puritan tradition. It was expressed, for example, by Anglican poet George Herbert (1593–1633), who shared some of the language and ideas of puritan church writers of his time in 'The Elixir', published after his death and popularised as a hymn. He wrote: 'All may of Thee partake: Nothing can be so mean, Which with his tincture – "for Thy sake" – Will not grow bright and clean. / A servant with this clause, Makes drudgery divine: Who sweeps a room as for Thy laws, Makes that and th'action fine'.[14]

Nicholson's commitment to complete concentration – an insistence on bringing together idea and action – is also reminiscent of the Zen Buddhist's application of mental discipline to become one with an activity. As Andrew Juniper has explained, in Zen, 'the artistry is the result of a mind focussed on the task in hand, whether it be polishing a floor, raking gravel, or cutting vegetables. By bringing the mind to bear on the here and now, everyday activities can take on profound meaning'.[15] This state of complete absorption in an activity has the effect of suppressing the ego, enabling body and mind to work freely and without constraint.

Nicholson rarely discussed philosophy or religion, but had a lifelong interest in developing the spiritual aspect of his work. Angela Verren Taunt, his companion for much of the 1970s, recalled that despite his indifference to organised religion, he 'had a mystical side to him with a deep belief in the next life and a profound faith in some sort of extraterrestrial power for good, and in the tremendous power

of thought – both for good and evil'.[16] His unorthodox spiritual beliefs may well have made him receptive to the ideas of Zen, and its expression in cultural practice and art through the concept of *wabi sabi*. Difficult to explain in Western terms, *wabi sabi* is an idea of beauty that developed to express the lives of Zen monks, giving form to such precepts as simplicity, humility, restraint, naturalness, joy, and the melancholy of life's impermanence.[17] Its material characteristics are the suggestion of natural process, irregularity, unpretentiousness, austerity and imperfection. Through the art of flower arranging and the tea ceremony, Zen aesthetics were assimilated into wider Japanese culture. In an essay of 1954, Soetsu Yanagi, a friend of the potter Bernard Leach, wrote about the beauty of irregularity at the heart of the tea ceremony. With regard to tea bowls he wrote:

A certain love of roughness is involved, behind which lurks a hidden beauty, to which we refer in our peculiar adjectives *shibui*, *wabi*, and *sabi*. Tea-bowls are not a project of the intellect. Yet their beauty is well defined, which is why it has been referred to both as the beauty of the imperfect and the beauty that deliberately rejects the perfect. Either way, it is a beauty lurking within.[18]

Such thinking parallels Nicholson's Christian Science-influenced belief in the spiritual reality hidden behind physical appearance.

Key to Zen thought is the recognition of impermanence, along with anti-intellectualism, an aversion to explanations, and an emphasis on the power of direct experience, all of which would have appealed to Nicholson. For example, he wrote: 'Klee's idea of going for a walk with a line is too pedestrian for my taste and I prefer Rafael's "perpetual motion" or flight into eternity'. He was also fond of quoting a remark by Braque that 'one can explain everything about a painting except the bit that matters'.[19] In 1944, recalling his encounter with a Cubist painting by Picasso in Paris in 1921, he commented on the direct impact of the

65
Ben Nicholson's
Studio, Hampstead,
June 1933

Tate Gallery Archive

miraculous green at its centre, '… none of the actual events in one's life have been more real than that, and it still remains a standard by which I judge any reality in my own work'.[20]

Others have perceived Nicholson's affinity with Japanese aesthetics. For example, in photographs of number 7 Mall Studios of the mid-1930s (fig.65), Sarah Jane Checkland has observed the placing of the artist's collection of pink and white spiralled Viennese pencils, which for her 'more than anything else demonstrate his near-Japanese sensibility when it came to the enjoyment, and immaculate ordering, of minutiae'.[21] This sense of placement or composition may well relate to the works of Joan Miró or Alexander Calder, but Nicholson's attention to what was left out of a composition, however unconsciously, strongly resembles Japanese style – compare for example *c.1927 (apples and pears)* (fig.68) and an early twentieth-century hanging scroll painted by Kobayashi Kokei (fig.66).

66
Kobayashi Kokei
'Fruit', hanging scroll, early 20th Century, Mineral pigments on paper

Collection of Yamatame Museum of Art, Tokyo

67
Bowl, brushmarked (hakeme) stoneware, Korea. Yi dynasty (17th Century)
Diameter 17.1

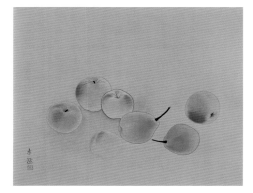

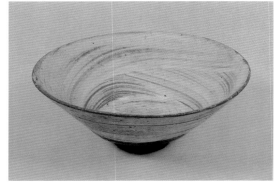

Making a direct connection between Nicholson's visual sensibility and Japanese aesthetics is speculative. However, it is more than possible that he became aware of *wabi sabi*, if not by name then perhaps through its manifestation in cultural artefacts, via his contact with Leach, who was known for his assimilation of Japanese aesthetics.[22] It is tempting, for example, to see a similarity between the lively brushwork evident in the white undercoat of such works as *1928 (Pill Creek)* (fig.69) and the irregular or variegated effect achieved by the coarse painting of thick white slip over dark clay practised by Korean potters when making *hakene* or 'brushmark'-style vessels for daily use in the seventeenth century (fig.67). Such effects were admired by Leach and Yanagi for their simplicity and naturalness.[23] Yet whether or not Nicholson was aware of the relationship between the aesthetic beauty of his weathered surfaces and the concept of *wabi sabi*, both his style and a *wabi sabi* aesthetic shared a similar aim.

For Nicholson, the working of a surface was pleasurable, and a direct means of expressing visual experience. The idea of 'visual fulfilment' was the prime motivation for his work, but this apparently selfish occupation paradoxically entailed, indeed demanded, a complete release from ego. With the dedication of a Zen monk he would apply himself to a task for hours on end and without a break, hoping that eventually the relief would take 'control of itself'.[24] Although dedicated to his art and its promotion, as he grew older Nicholson was increasingly critical of the 'personality worship' of artists and their own seduction by celebrity and fame,

which he felt was a major obstacle to the achievement of freshness, a childlike sense of discovery, and the pursuit of truth.[25] Despite the great sophistication of his work, this remained a singular goal.

His aesthetic was honed by a work ethic – consciously inherited from his mother – that coalesced with his genuine desire to make the world a better place through art. Ironically, Nicholson's facility for creating beautiful surfaces has contributed to the view that he was as tasteful as his father, and that this somehow represents a limitation in his work. He may well have inherited his father's aesthetic sensibility.[26] But what is interesting about Nicholson's work is the tension created between a characteristically restrained use of colour, lack of pictorial clutter, exacting use of line, and the visible physical battering of the surface or support. His works have a delicate beauty, made all the more vulnerable by their eroded, incised and abraded surfaces.

Nicholson comes across as a restless figure. He moved around, travelled, produced two families and was married three times. As an artist he was constantly searching for truth, trying to improve. This state of flux was held in check by a disciplined work routine that he established in the 1920s. The mundane nature of his routine grounded his practice in physical activity, which he saw as a way into the world of spiritual reality. It became an anchor, a rock on which to depend. Nicholson's weathered surfaces signify a down-to-earthness. At the same time, they denote the passing of time, a wistful, even melancholic recognition that nothing can last forever. He, like others, felt this acutely when the Second World War interrupted his life, thwarting ambitions and souring aspirations. Far from being a cold, unfeeling artist, he was perhaps – as Richard Dorment has suggested – a 'poet of ephemeral pleasures'.[27]

At the core of Nicholson's work was a commitment to conveying what he believed to be vital and alive. In some ways the feeling for landscape and location which permeates the late reliefs represents a fulfilment of an interest he had initially explored with Winifred and Christopher Wood. It is connected to his enduring pursuit of a primitive, instinctive approach, in which remembered and present experience intermingle to produce an understated yet poignant visual poetry.

Notes

INTRODUCTION

1 Charles Harrison, *English Art and Modernism 1900–1939*, London 1981, 2nd edition 1994, p.176.

2 Patrick Heron, *The Changing Forms of Art*, London 1955, p.188.

3 Sarah Jane Checkland, Nicholson's biographer, provides a detailed account of archive material pertaining to the artist in *Ben Nicholson: The Vicious Circles of his Life and Art*, London 2000, pp.xix–xx.

4 He was married to Winifred 1920–38, Barbara 1938–51 and Felicitas 1957–77.

5 Andrew Nicholson (ed.), *Unknown Colour: Paintings, Letters, Writings by Winifred Nicholson*, London 1987, p.6.

1 LIFE AND WORK: AN OVERVIEW

1 Margaret Gardiner, 'A Portrait of Ben Nicholson', *Modern Painters*, vol.2, no.1, spring 1989, p.42.

2 Myfanwy Piper, 'Back in the Thirties', *Art and Literature*, winter 1965, pp.143, 147; Cyril Reddihough, *Memoirs of Ben Nicholson*, letter 17 March 1985, TGA 8514.3.

3 Sarah Jane Checkland, *Ben Nicholson: The Vicious Circles of his Life and Art*, London 2000, p.xxi. When Ben and Barbara's triplets Simon, Rachel and Sarah were born in October 1934, they were put into private care so that Barbara could continue to work. By all accounts, Ben demonstrated little in the way of responsibility towards his six children.

4 Catherine M. Saussloff, *The Absolute Artist: The Historiography of a Concept*, University of Minnesota Press, London 1997, p.155.

5 Letter to Geoffrey Jellicoe, 17 April 1967, TGA919.15.

6 Ben had three younger siblings: Antony b.1897, Nancy b.1899, and Christopher b.1904.

7 Jeremy Lewison, *Ben Nicholson*, exh. cat., Tate Gallery 1993, p.11.

8 His first one-man exhibition in 1924 at London's XXI Gallery was met with a review in the *Daily Mail* on 7 March, entitled 'The Prodigal Son'.

9 John Summerson, *Ben Nicholson*, Middlesex 1948, p.13.

10 'Ben Nicholson in Conversation with Vera and John Russell', *Sunday Times*, 28 April 1963.

11 Letter to John Summerson dated 3 Jan. [1944], TGA.

12 Letter to Herbert Read, n.d. [1944], copy, TGA 8717.1.3.

13 Reddihough 1985, letter, TGA 8514.3.

14 *Sunday Times*, 28 April 1963.

15 Jeremy Lewison has documented the effect father and son had on each other's work in Lewison, 1993, p.14, and *Ben Nicholson: The Years of Experiment 1919–39*, exh. cat., Kettle's Yard Gallery, Cambridge 1983, pp.10–11.

16 See Chris Stephens, 'Ben Nicholson: Modernism, Craft and the English Vernacular' in *The Geographies of Englishness: Landscape and the National Past 1880–1940*, ed. David Peters Corbett, Ysanne Holt and Fiona Russell, New Haven and London 2000, pp.225–47, p.243. This interpretation is discussed more fully in chapter 2.

17 Lewison 1993, p.20.

18 However Ben, like his father, expressed his 'bohemian' persona through sartorial eccentricity, apparently embarrassing his in-laws with his brightly coloured clothes (see Checkland 2000, pp.49, 59).

19 The doctrines of the Christian Science church are expressed through Eddy's books *Science and Health and Key to the Scriptures*. In Christian Science terminology, 'Spirit is immortal Truth; matter is mortal error/ Spirit is the real and eternal; matter is the unreal and temporal'.

20 Checkland 2000, p.65.

21 Other members of the group included, at different times, such artists as Winifred Nicholson, Christopher Wood, Barbara Hepworth, John Piper, Frances Hodgkins, Henry Moore and David Jones.

22 See Lewison 1983, p.14 and Lewison 1993, pp.24–6.

23 Wood's impact on Ben and Winfred has been well recorded (see Lewison 1993, pp.34–5).

24 Matthew Gale has demonstrated that Ben and Kit's legendary 'discovery' of Wallis erroneously suggests that Wallis was unaware that he was making art. Furthermore the painter Cedric Morris claims to have known about Wallis prior to Nicholson and Wood (see Gale, *Alfred Wallis*, London 1998, pp.21, 68).

25 See Lewison 1993, p.37.

26 They shared a studio until summer 1936 when, owing to Barbara's smoking and Ben's need for solitude, he moved his studio to the shed in the garden of 60 Parkhill Road. Ben Nicholson, letter to Geoffrey Jellicoe, 22 April [1967], TGA 919.6.

27 Letter to Helen Sutherland, 3 May 1932, Helen Sutherland Archive, on loan to TGA.

28 The British economy was in slump and Ben relied heavily on friends and patrons such as Helen Sutherland and Jim Ede for financial assistance. In 1934, still in difficulty, his father offered him £10 a month and continued to help out for the rest of the decade.

29 Quoted in Norbert Lynton, *Ben Nicholson*, London 1993, paperback edition 2003, p.45.

30 See Lewsion 1993, p.30.

31 Lewison, ibid., p.213; Checkland 2000, p.120.

32 Ben Nicholson, 'Notes on Abstract Art', *Horizon*, vol.iv, no.22, October 1941, pp.274–5.

33 He later recalled that Arp's free sculptural forms, Calder's mobiles and Miró's freedom of painting had the most significant impact on his work. See Charles Harrison, *English Art and Modernism 1900–1939*, New Haven and London 1981, 2nd edition 1994, p.259.

34 Quoted in Checkland 2000, p.119. It is important to note that modern continental art was virtually invisible to the general public at this time. For example, the National Gallery of British Art at Millbank (now Tate Britain) opened its first modern foreign gallery in 1926, and until the Stoop bequest of 1933 it contained few examples from the twentieth century (the basis of the collection now shown at Tate Modern).

35 Lewison 1993, p.41.

36 Lewison, ibid., p.218; Checkland 2000, p.132.

37 The members included architects Wells Coates, Colin Lucas, sculptors Hepworth, Moore, and artists Nash, Nicholson, Edward Wadsworth, John Armstrong, John Bigge, Edward Burra and Frances Hodgkins, who soon resigned to be replaced by Tristram Hillier.

38 Paul Nash, letter to *The Times*, 12 June 1933, and *Listener* 5 July 1933; see Harrison 1994, pp.240–1, 250.

39 The exhibitors included Francis Butterfield, Winifred Dacre (Nicholson), Barbara Hepworth, Ivon Hitchens, Eileen Holding, Arthur Jackson, Henry Moore, William Staite Murray, Ben Nicholson, Roland Penrose and John Piper.

40 Quoted in Harrison 1994, p.285.

41 Leslie Martin, 'Architecture and the Painter, with special reference to the work of Ben Nicholson', *Focus*, no.3, 1939.

42 This was possibly because Gabo, provider of a theoretical model, left for America in November 1946 (Margaret Garlake, *New Art New World: British Art in Postwar Society*, New Haven and London 1998, p.158).

43 Letter to Margot Eates and Hartley Ramsden, n.d. [summer 1951] TGA 9130. Ben moved from the family home in Carbis Bay to Trezion in Salubrious Place in spring 1955, while Barbara had already moved to St Ives in 1950.

44 'Mr Ben Nicholson Answers some Questions about his Work and Views', *The Times*, 12 November 1959, reprinted in *Studio* special 1969, p.46.

45 Quoted in John Russell, *Ben Nicholson*, London 1969, p.33.

46 Letter 30 October [1963], TGA.

47 Russell 1969, p.40.

48 Quoted in *Ben Nicholson*, exh. cat., Tate Gallery 1955.

49 See Lewison 1993, p.90.

50 John Russell 1969, p.39.

51 See Lynton 1993, p.168. He also admired the work of Antoni Tapies and Alberto Burri.

52 Ibid., p.168. Writing to Herbert Read in the mid-1960s Nicholson declared that the landscape and sea of West Penwith had permeated his existence (see Checkland 2000, p.339).

2 1930S: THE WHITE RELIEFS

1 Herbert Read, *Ben Nicholson, Paintings, Reliefs, Drawings*, London 1948, reprinted 1955 as *Ben Nicholson, Vol.1: Work from 1911–1948*, p.25.

2 Waldemar Januszczak, 'Driven by Abstraction', *Sunday Times*, 17 October 1993, p.12.

3 See Charles Harrison, *English Art and Modernism 1900–1939*, New Haven and London 1981, 2nd edition 1994, p.259.

4 *Ben Nicholson: Drawings, Paintings and Reliefs 1911–1968*, introduction by John Russell, London 1969, p.26.

5 Although Nicholson's engagement with continental modernism has been well documented, his role in efforts to develop a specifically English modernity has largely been overlooked. This is because until fairly recently the history of English visual art of the early twentieth century has been regarded primarily as a narrative in which English art is discussed in terms of its ability to assimilate the theory and practice of the international avant-garde.

6 Chris Stephens, 'Ben Nicholson: Modernism, Craft and the English Vernacular' in *The Geographies of Englishness: Landscape and the National Past 1880–1940*, ed. David Peters Corbett, Ysanne Holt and Fiona Russell, New Haven and London 2000, pp.225–47. Nicholson expressed his desire to make art with 'grass roots' in a letter to Read, 24 Jan. [1936], copy TGA 8717.1.3.

7 Letter to Charles Harrison 1968, TGA 839. Jeremy Lewison has noted that there is no contemporary account of this event: it seems likely that he would have reported this significant development to Hepworth in a letter (Lewison, *Ben Nicholson*, exh. cat. Tate Gallery 1993, p.40)

8 He had particularly enjoyed the process of carving lino blocks for fabric designs with Hepworth earlier that year.

9 See Norbert Lynton, *Ben Nicholson*, London 1993, paperback edition 2003, p.68. Nicholson also compared his

early attempts at carving to children's games, and was perhaps aware of Giacometti's sculptures of the early 1930s resembling primitive games (Lewison 1993, p.41).

10 Annette King, 'Ben Nicholson's *1935 (white relief) 1935*' in *Paint and Purpose: A Study of Technique in British Art*, eds. Stephen Hackney, Rica Jones and Joyce Townsend, London 1999, p.161.

11 The Golden Section, the name given to Euclid's division of a line into an 'extreme and mean ratio', was promoted in the fifteenth century as the 'divine proportion'. Experiments have shown that most designs developed from the square and using compasses will result in the proportions of the Golden Section (Harold Osborne, *The Oxford Companion to Art*, 1970, reprinted 1984, pp.488–9).

12 The impact of the international avant-garde on the white reliefs has been well documented; see, for example, Harrison 1994, pp.258–60 and Lewison 1993, pp.39–41.

13 Quoted in Lewison 1993, p.41.

14 Clive Bell first developed the theory of 'significant form' in his book *Art* (1914), which stressed the relative unimportance of subject matter. Roger Fry became associated with Bell's term, which he helped to establish, although he later modified its emphasis on pure form, as for example in *Vision and Design* (1920).

15 David Gascoyne, 'Art', *New English Weekly*, vol.5, no.3, 3 May 1934, p.66.

16 See Sarah Jane Checkland, *Ben Nicholson: The Vicious Circles of his Life and Art*, London 2000, p.149.

17 Geoffrey Grigson, 'Comment on England', *Axis*, no.1, 1935, pp.8–10 and Hugh Gordon Porteus, 'Mr Ben Nicholson', *New English Weekly*, vol.7, no.21, 3 October 1935, p.414. As Jeremy Lewison has noted, for his critics Nicholson's sterile reliefs also resembled the formulaic aesthetic of science, and like science, abstract art had become too specialised and remote (Lewison, *Ben Nicholson: The Years of Experiment 1919–39*, exh. cat, Kettle's Yard Gallery, Cambridge 1983, p.34).

18 Nicholson was not politically motivated, although his sympathies were vaguely left-wing.

19 Herbert Read, 'On Ben Nicholson's Recent Work', *Axis*, no.2, April 1935, pp.15–18, p.15. Nicholson's interest in surface is further discussed in chapter 4.

20 Ibid., p.16.

21 Paul Nash, 'Ben Nicholson's Carved Reliefs', *Architectural Review*, vol.78, no.467, October 1935, pp.142–43.

22 Coates became the designer for the Isokon company formed in 1931 to produce modern houses, flats and furniture (see Lynton 2003, p.69).

23 Quoted in Lewison 1993, p.47.

24 Herbert Read, *Art and Industry: The Principles of Industrial Design*, London 1934, second edition 1944, p.53.

25 See Lewison 1993, p.52 and Harrison 1994, pp.288–9.

26 Quoted in David Mellor, 'British Art in the 1930s: Some Economic, Political and Cultural Structures', *Class, Culture and Social Change: A New View of the 1930s*, ed. Frank Gloversmith, Sussex and New Jersey 1980, pp.186–7.

27 Paul Nash, 'Going "Modern" and Being "British"', *The Weekend Review*, no.12, February 1932, p.333.

28 Jean Hélion, 'Ben Nicholson: Memoirs by his Friends', April 1969, TGA.

29 David Thistlewood in *Herbert Read: A British Vision of World Art*, eds. Benedict Read and David Thistlewood, London 1993, p.76.

30 See *The English Vision: An Anthology*, ed. Herbert Read, London 1939, pp.vi, vii. Such publications included, for example, *English Stained Glass* (London 1926) and *Staffordshire Pottery Figures* (London 1929). Read continued to hold such views in the 1930s, proposing, for example, that the down-to-earth functionalism of rustic, pre-industrial English domestic ware could usefully inform modern design (Read 1944, p.53). Paul Nash also attempted to make connections between the modern movement and the history of British design in *Room and Book* (1932), although he traced modernism to Regency rather than medieval design (see Fiona Russell, 'John Ruskin, Herbert Read and the Englishness of British Modernism' in *The Geographies of Englishness*, 2000, p.312).

31 Herbert Read, *Grass Roots: Lectures on the Social Aspects of Art in an Industrial Age*, New York 1946, revised edition London 1955, p.33.

32 Letter to Ede, 29 March [1937] printed in *Kettle's Yard and its Artists: An Anthology*, compiled by Matthew Gale, Kettle's Yard, Cambridge 1995, p.45. Interestingly, his work, when appreciated abroad in the post-war period, was admired for its English qualities, namely simplicity, restraint and decisive line.

33 Stephens 2000, pp.229–30.

34 Bernard Rackham and Herbert Read, *English Pottery: Its Development from Early Times to the End of the Eighteenth Century*, London 1924, p.4.

35 See Gillian Naylor, 'Modernism and Memory: Leaving Traces' in *Material Memories: Design and Evocation*, eds. Marius Kwint, Christopher Breward and Jeremy Aynsley, London 1999, p.98.

36 See Stephens 2000, p.237.

37 Winifred Nicholson, 'Influence and Originality', reproduced in *Unknown Colour*, ed. A. Nicholson, London 1987, p.55.

38 The Nicholsons' pursuit of simplicity at home has led Stephens to consider Ben Nicholson's white reliefs in the context of this broader ambition to modernise everyday life (Stephens 2000, p.239).

39 Cyril Reddihough, letter dated 17 March 1985, TGA 8514.

40 Letter to John Summerson, 3 January [1944], John Summerson Archive, on loan to Tate Gallery. The Bloomsbury Group had also expressed modernity through their lifestyle, rejecting conventional personal relationships and radicalising their domestic spaces (see Christopher Reed, '"A Room of One's Own": The Bloomsbury Group's Creation of a Modernist Domesticity' in *Not at Home: The Suppression of Domesticity in Modern Art and Architecture*, ed. Christopher Reed, London 1996).

41 Stephens 2000, pp.241–2.

42 *Carvings by Barbara Hepworth, paintings by Ben Nicholson*, with introductions by Herbert Read and H.S. Ede, exh. cat., Arthur Tooth, London, 9 November to 3 December 1932.

43 W. Kandinsky, *Concerning the Spiritual in Art*, trans. M.T.N. Sadler, London 1914, Dover edition 1977, p.39, and letter

to John Summerson 3 January 1944, both quoted in Lewison 1983, p.33.

44 Ben's belief in the higher purpose of art coalesced with the spiritual idealism underpinning the work of such European exponents of abstraction as Piet Mondrian, whose own theory of art, 'Neoplasticism', was not just a painting style but a philosophy and religion. Rooted in Dutch Calvinism and the mysticism of Theosophy, Mondrian believed in the existence of universal harmony. His arrangements of line, space and colour aimed to reflect these universal principles, and so doing, transform life, as he asserted: 'In the future, the tangible embodiment of pictorial values will supplant art. Then we shall no longer need paintings, for we shall live in the midst of realized art' (Herschel B. Chipp, *Theories of Modern Art*, Berkeley 1968, p.315).

45 See Andrew Wilson, 'Ben Nicholson', *Art Monthly*, October 1993, p.18.

46 Ibid., p.18.

47 See Checkland 2000, p.127. She notes, for example, that in one of his notebooks Ben jotted a passage from *Science and Health*, the Christian Science handbook, 'Mind is perpetual motion. Its symbol is the sphere. The rotations and revolutions of the universe of mind go on eternally' (p.126).

48 Unit One, 1934, quoted in full in Lynton 2003, pp.50–1. Checkland notes that Herbert Read failed to understand this aspect of Ben's work at the time (ibid., p.134).

49 Checkland 2000, p.160.

50 Ben Nicholson, 'Quotations' in *Circle: International Survey of Constructive Art*, eds J.L. Martin, B. Nicholson and N. Gabo, London 1937, p.75.

51 Letter to Geoffrey Jellicoe, 24 May [1967], TGA 919.9.

52 Ben Nicholson, 'The aim of the modern artist', *Studio*, vol.104, no.21, December 1932, p.333. For a discussion of the use of the term 'idea' with regard to Nicholson's work in the late 1920s see Lewison 1983, p.23.

53 Lewison quotes Mary Baker Eddy on the idea of mortals evolving thought in *Science and Health with Key to the Scriptures*, 1875, Lewison 1993, p.26.

54 Ben Nicholson in *Ben Nicholson: Paintings, Reliefs, Drawings Vol.1911–48*, introduction

by Herbert Read, London 1948, reprinted 1955, pp.25–6.

55 Ben Nicholson, 'Artist's statement' in D.K. Baxandall, *Ben Nicholson*, London 1962.

56 Ben Nicholson, *Ben Nicholson*, exh. cat., Galerie Beyeler Basel, April–June 1968, unpag.

57 As Charles Harrison has noted, Nicholson's white reliefs should be understood 'as much in relation to an tendency to topicalise as 'artistic' such memories as the snow and sunlight in the Ticino in the early twenties, or the light reflected from whitewashed cottages in St Ives in 1928, or the white-painted studios of Arp and Brancusi in 1932–3, as the Modern Movement's stylistic preference for white buildings with slablike walls' (Harrison 1994, p.264).

58 Ben Nicholson quoted by John Russell in *Ben Nicholson*, Marlborough Gallery, London 1963, p.8.

59 Wilson 1993, p.19.

3 ST IVES: ABSTRACTION VERSUS REALISM IN THE 1950S

1 Quoted in Margaret Gardiner, 'A Portrait of Ben Nicholson', *Modern Painters*, vol.2, no.1, spring 1989, p.44.

2 Letter to Herbert Read 18/3/1965 HRA (152), see Sarah Jane Checkland, *Ben Nicholson: The Vicious Circles of his Life and Art*, London 2000, p.339.

3 Letter to Paul Nash, 4 December 1939, TGA.

4 Ibid.

5 Ben Nicholson, 'Notes on Abstract Art', *Horizon*, no.22, 1941, pp.272–5, p.272.

6 David Lewis, 'Ben Nicholson's *Feb.18–54 (azure)*', *Carnegie Magazine*, May 1978, p.10.

7 Letter to Patrick Heron, 9 February 1954, TGA, in Jeremy Lewison, *Ben Nicholson*, exh. cat. Tate Gallery 1993, p.75.

8 Jeremy Lewison, *Ben Nicholson*, exh. cat. Foundation Pierre Gianadda, Martigny Switzerland 1992, p.43.

9 Letter to Patrick Heron, 9 February 1954, TGA.

10 See John Russell, *Ben Nicholson*, London 1969, p.37.

11 Ibid., p.9.

12 *Statements*, exh. cat. Institute of Contemporary Arts London, printed in Maurice de Sausmarez,

Ben Nicholson – Studio International, London and New York (Studio International Special) 1969, p.40.

13 Ibid., p.40.

14 See Checkland 2000, p.238.

15 This new group, emerging in 1951, initially comprised Kenneth Martin, Mary Martin, Anthony Hill, Adrian Heath and Robert Adams. They produced abstract paintings and geometric construction reliefs using such manmade materials as plastic and metal. Interested in the idea of a logical process of growth upon which art could be based, they explored such mathematical systems as the Fibonacci series and the Golden Mean.

16 See Herbert Read, 'Realism and Abstraction in Modern Art', in *The Philosophy of Modern Art*, 1952 and *Art and Society*, London, Faber and Faber, revised edition 1945, p.125.

17 Quoted in Margaret Garlake, *New Art New World: British Art in Postwar Society*, New Haven and London 1998, p.36.

18 Ibid., p.38.

19 John Berger, 'The Limits of Dumbness', *New Statesman and Nation*, 16 July 1955.

20 John Rothenstein, *Modern English Painters*, vol.II: Lewis to Moore (1st published 1956), 2nd edition 1976, pp.277, 281.

21 Patrick Heron, 'English and French in 1950', *New Statesman*, vol.39, no.983, 7 January 1950, pp.9–10.

22 See James Hyman, *The Battle for Realism: Figurative Art in Britain During the Cold War 1945–1960*, New Haven and London 2001, p.24.

23 Reprinted in *Ben Nicholson – Studio International* 1969, p.40.

24 Herbert Read, 'A Gentle Nest of Artists', *Apollo*, vol.76, no.7, September 1962, p.536–8. To avoid partisan associations in his writing he later referred to constructivism more generally as abstraction, and surrealism as superrealism, his own term describing vanguard art derived from subjective or psychological impulses.

25 David Thistlewood, 'Herbert Read's Paradigm: A British Vision of Modernism' in *Herbert Read: A British Vision of World Art*, eds Benedict Read and David Thistlewood, exh.cat., Leeds City Art Galleries, London 1993, p.84.

26 At fifty-four years old Nicholson had produced a

substantial body of work, yet he felt he had yet to convince a wider public of the validity of his endeavour. He saw publications as key to rectifying the situation. Reprinted in 1955, the lavish monograph was supervised and laid out by the artist with an introduction by Read. Together with a more populist Penguin book of 1948 (introduced by his brother-in-law John Summerson), it helped to re-establish Nicholson's post-war reputation.

27 He wrote: 'It will be part of my argument that the abstract movement in modern art corresponds to a certain psychological necessity which is widely diffused in the world to-day, and it is therefore idle to speculate on priorities in the formulation of a modern abstract style' (quoted in Herbert Read, *Ben Nicholson: Paintings, Reliefs, Drawings, 1911–48*, vol.1, London 1948, reprinted 1955, p.13).

28 Herbert Read, *Ben Nicholson* 1948, published as ch.12 in *The Philosophy of Modern Art* 1952, pp.216–25, p.220.

29 Read 1955, p.17.

30 Ibid., p.27.

31 Letter to Lillian Somerville, 25 or 26 March 1954, TGA 883.2.

32 See Lewison 1993, p.82.

33 See Robert Geerts, *Le Derniere Heure*, Brussels, March 1955, Emily Genauer, 'Venice Biennale', *New York Herald Tribune*, 15 August 1954 and Leon Degand, *Aujourd'hui*, no.7, Paris, March 1956, all printed in *Ben Nicholson: Works since 1947*, vol.2, with an introduction by Herbert Read, London 1956, unpag.

34 See Margaret Garlake, *New Art New World: British Art in Postwar Society*, New Haven and London 1998, p.158.

35 Quoted in Checkland 2000, p.255.

36 Letter to Alan Bowness, 16 January 1983, Tate Conservation Records

37 Lewison 1992, p.42.

38 Patrick Heron, 'The Visual Arts', *Architect's Yearbook*, no.3, 1949, p.21 and 'Ben Nicholson', *New Statesman and Nation*, 16 May 1952, p.584.

39 See Patrick Heron, 'Space in Contemporary Painting and Architecture', *The Architect's Yearbook*, January 1953, reprinted in Patrick Heron, *The Changing Forms of Art*, London 1955, pp.40–5.

40 Patrick Heron, 'Ben Nicholson' from articles published in 1945, 1947 and 1952, in *The Changing Forms of Art*, London 1955, p.191.

41 Garlake 1998, p.163.

4 A KIND OF BEAUTY: NICHOLSON'S AESTHETIC STYLE

1 John Rothenstein, *Modern English Painters*, vol.11, Lewis to Moore (1st published 1956), 2nd edition 1976, pp.280–1.

2 Andrew Graham Dixon, 'Done up like a Kipper', *Independent*, Tuesday 19 October 1993, p.25. See also William Packer, 'Nicholson in Perspective', *Financial Times*, Tuesday 19 October 1993, p.19.

3 Charles Harrison, *English Art and Modernism 1900–1939*, New Haven and London 1981, 2nd edition 1994, p.182.

4 Peter Khoroche, *Ben Nicholson: 'chasing out something alive'*, exh. cat., Kettle's Yard, Cambridge 2002, p.22.

5 Unless otherwise stated, all information regarding Nicholson's working process and the physical properties of his works has been ascertained from Tate conservation files, and from conversations between the author and Mary Bustin, Tate conservator, in July 2005.

6 Letter to John Summerson, 25 April 1944, quoted in Jeremy Lewison, *Ben Nicholson: The Years of Experiment 1919–39*, exh. cat., Kettle's Yard Gallery, Cambridge 1983, p.21.

7 Paul Nash, 'Goings on: a painter and a sculptor', *Weekend Review*, vol.6, no.141, 19 November 1932, p.613.

8 Adrian Stokes, 'Mr Ben Nicholson's Painting', *Spectator*, October 1933, reprinted in *The Critical Writings of Adrian Stokes 1930–37*, London and Plymouth 1978, pp.307–8.

9 Nicholson quoted in *Ben Nicholson*, exh. cat., Galerie Beyeler, Basel, April–June 1958, unpag.

10 Quoted in *Ben Nicholson: Drawings, Paintings and Reliefs 1911–1968*, with an introduction by John Russell, London 1969, p.35.

11 Late in life he particularly admired the work of Alberto Burri and Antoni Tapies for their rough surfaces, but also for their intuitive use of 'defects' and 'incidentals'; see letters to Geoffrey Jellicoe, 17 December

[1970] and 3 January [1971], TGA 919.78 & 919.79.

12 Letter to Alan Bowness, 16 January 1983, p.3, Tate Conservation records.

13 Russell 1969, p.12.

14 George Herbert, *The Temple, Sacred Poems and Private Ejaculations*, ed. N. Ferrar, Cambridge 1633; facsimile edition London 1968.

15 Andrew Juniper, *Wabi Sabi: The Japanese Art of Impermanence*, Boston, Rutland, Vermont and Tokyo 2003, p.91.

16 Angela Verren Taunt, 'Memoirs of Ben Nicholson', TGA 8514.4, p.9.

17 The affinity of Nicholson's aesthetic style with wabi-sabi may in part explain why his work is so well received in Japan.

18 Soetsu Yanagi, *The Unknown Craftsman: A Japanese Insight into Beauty*, adapted by Bernard Leach, Kodansha International: Japan 1972, revised edition 1989, p.123. Juniper has summed up *wabi sabi* as 'an intuitive appreciation of a transient beauty in the physical world that reflects the irreversible flow of life in the spiritual world. It is an understated beauty that exists in the modest, rustic, imperfect, or even decayed, an aesthetic sensibility that finds a melancholic beauty in the impermanence of all things' (Juniper 2003, p.27).

19 Both quotes in exh. cat., Galerie Beyeler 1958, unpag.

20 Quoted in Harrison 1994, p.178.

21 Sarah Jane Checkland, *Ben Nicholson: The Vicious Circles of his Life and Art*, London 2000, p.154.

22 Although it is thought that Nicholson and Hepworth did not meet Leach until their move to St Ives, where Leach had established a studio since the 1920s, they most likely met in the mid-1920s, as they shared the same milieu (see Chris Stephens, 'Ben Nicholson: Modernism, Craft and the English Vernacular', in *The Geographies of Englishness: Landscape and the National Past 1880–1940*, eds. David Peters Corbett et al., New Haven and London 2000, pp.233–4).

23 The naturalness of Korean peasantware was greatly admired by the Japanese. Yanagi argued the superiority of Korean ware for use in the tea ceremony, since it was made without pretension

(see Yanagi 1989, pp.121–5, 171–2). As early as 1915, Leach identified the Japanese tendency to perceive beauty underlying simple, unrefined appearances (see Emmanuel Cooper, *Bernard Leach: Life and Work*, New Haven and London 2003, p.100). Emmanuel Cooper, Leach's biographer, suggests that the potter was sympathetic towards Ben's work until the mid-1950s, when he became disillusioned with the art shown by the Penwith Society of Arts, of which he had been a founder member (ibid., pp.233, 278).

24 Letter to Geoffrey Jellicoe, 20 November [1967], TGA 919.22.

25 See Letter to Geoffrey Jellicoe, 28 January [1970], TGA 919.65, in which he is critical of Picasso, Hepworth and Moore for being too fond of publicity.

26 Interestingly, as a 'Whistlerian' artist, William Nicholson's picture-making was in fact influenced by Japanese style.

27 Richard Dorment, 'The Poet of Remembered Dreams', *Daily Telegraph*, 20 October 1993, p.14.

Photographic Credits & Copyright

Select Bibliography

Jon Blackwood, *Winifred Nicholson*, exh. cat., Kettle's Yard Gallery, Cambridge 2001

Sarah Jane Checkland, *Ben Nicholson: The Vicious Circles of his Life & Art*, London 2000

Matthew Gale (ed.), *Kettle's Yard and its Artists: an Anthology*, Kettle's Yard, Cambridge 1995

Margaret Garlake, *New Art New World: British Art in Postwar Society*, New Haven and London 1998

Charles Harrison, *English Art and Modernism 1900–1939*, London 1981, 2nd edition 1994

Charles Harrison, *The Modern, The Primitive and the Picturesque: Alfred Wallis, Christopher Wood, Ben Nicholson*, exh. cat., Scottish Arts Council, Edinburgh 1987

Patrick Heron, *The Changing Forms of Art*, London 1955

Peter Khoroche, *Ben Nicholson: 'Chasing out something Alive' (Drawings and Painted Reliefs 1950–75)*, exh. cat., Kettle's Yard Gallery, Cambridge 2002

Jeremy Lewison, *Ben Nicholson: The Years of Experiment 1919–39*, exh cat., Kettle's Yard Gallery, Cambridge 1983

Jeremy Lewison, *Ben Nicholson*, exh. cat., Tate Gallery, 1993

Norbert Lynton, *Ben Nicholson*, London 1993

Leslie Martin, Ben Nicholson, Naum Gabo (eds.), *Circle, International Survey of Constructive Art*, London 1937

Ben Nicholson, 'Notes on Abstract Art', *Horizon*, vol.4, no.22, Oct. 1941, pp.272–6

Ben Nicholson, *Ben Nicholson*, exh. cat., Galerie Beyeler, Basle, April–15 June 1968

Ben Nicholson, 'Memoirs: William Nicholson', *London Magazine*, vol.7, no.3, June 1967, pp.69–73

Herbert Read (ed.), *Ben Nicholson: Paintings, Reliefs, Drawings*, London 1948

Herbert Read, *The Philosophy of Modern Art*, London 1952

Herbert Read (ed.), *Ben Nicholson: Work since 1947*, vol.2, London 1956

John Rothenstein, *Modern English Painters*, vol.2, London 1956, 2nd edition 1976

John Russell, *Ben Nicholson, Drawings, Paintings and Reliefs 1911–68*, London 1969

Maurice de Sausmarez (ed.), 'Ben Nicholson', *Studio International* (special edition), London 1969

Chris Stephens, 'Ben Nicholson: Modernism, Craft and the English Vernacular' in *The Geographies of Englishness: Landscape and the National Past 1880–1940*, David Peters Corbett, Ysanne Holt and Fiona Russell (eds.), Yale University Press, New Haven and London, 2000

John Summerson, *Ben Nicholson*, Middlesex 1948

Denys Val Baker, *Britain's Art Colony by the Sea*, 1959, new edition Samson, Bristol 2000

Soetsu Yanagi, *The Unknown Craftsman: A Japanese Insight into Beauty*, foreword by Shoji Hamada, adapted by Bernard Leach, Kodansha International, New York, 1972, revised edition 1989

Index

1919 (blue bowl in shadow) 12; fig.4
1921–c.1923 (Cortivallo, Lugano) 13; figs.8, 60
1923 (Dymchurch) 13; fig.9
1924 (first abstract painting) 17; fig.11
1924 (goblet and pears) 46; fig.43
1924 (painting – trout) 17
c.1927 (apples and pears) 72; fig.68
1928 (foothills, Cumberland) 17; fig.12
1928 (Pill Creek, Cornwall) 19, 73; fig.69
1928 (Porthmeor Beach, St Ives) 65; fig.14
1929 (Holmhead, Cumberland) fig.59
1931–6 (still-life – Greek landscape) 51
1932 (Au Chat Botté) 20–1, 38; fig.18
1932 (crowned head: the queen) fig.15
1932 (Le Quotidien) 68; fig.62
1932 (painting) fig.37
1933 (6 circles) 38; fig.36
1933 (guitar) fig.1
1933 (musical instruments) 24; fig.19
1933 (painting – milk and plain chocolate) 38; fig.38
1933 (St Remy, Provence) fig.17
1933 (study for a head) 37; fig.34
1934 (white relief) 43; figs.40, 41
1934 (white relief – circle and square) fig.39
1934 (white relief – triplets) fig.42
1935 (white relief) 44, 46; fig.31
1940 (Cornish landscape) 50; fig.44
1941 (painted relief – version 1) 51; fig.45
1944 (Higher Carnstabba Farm) 27; fig.21
1945 (parrot's eye) 51; fig.46
1953 February (contrapuntal) 53
1954, July 30 (Rome) fig.54
1959 (Argolis) 53; fig.51
1966 (Carnac – red and brown) 32; fig.28
1966 (Zennor Quoit 2) 33; fig.64
1967 (Tuscan relief) fig.63

A

abstraction 7, 8, 10, 17, 24, 26–7, 32, 35, 42, 47–8, 49–51, 58–62, 65
Abstraction-Création 24, 38
aesthetic style, Nicholson's 8, 12, 44, 65–74
Alloway, Lawrence 59
American Abstract Expressionism 8
American Action painting 58, 69
April 22 1979 (ivory) 34; fig.30
Arp, Jean (Hans) 24, 33, 38
 Constellation 38; fig.35
Arts and Crafts movement 42
August 1956 (boutique fantastique) 28; fig.22
August 1956 (Val d'Orcia) 29, 58; fig.53

B

Banks Head 16, 17, 34, 44
Barns-Graham, Wilhelmina 63, 70
Barrie, J.M. 10
Bauhaus 41
Beerbohm, Max 10
Beggarstaff, J. & W. 11
Bell, Clive 17, 38
Berger, John 59
Berlin, Sven 62–3
Biomorphism 24
Bissier, Julius 33
Bomberg, David 13
Bonington, Richard Parkes 62
Bonnard, Pierre 60
Brancusi, Constantin 24
Braque, Georges 13, 20, 24, 33, 38, 51, 58, 60, 63, 65, 66, 71
 Studio II (Atelier II) 53; fig.48
British Council 28, 30
Brumwell, Marcus 34

C

Calder, Alexander 24, 26, 38, 72
Carlisle, George Howard, 9th Earl 12
Cézanne, Paul 13, 58, 61
Checkland, Sarah Jane 7, 9, 46–7, 72
Christian Science 7, 13, 16, 25, 46–8, 71
Circle 26–7, 42, 47
Clark, Kenneth 38, 41
Claude Lorrain 46
Coates, Wells 41
Cocteau, Jean 17
Constable, John 62
constructive abstraction 58, 60
Constructivism 7, 24, 27, 35, 43, 62
Cornwall 6, 8, 19, 27–31, 34, 49–64
correspondence 6, 10
craft tradition 7, 42–4
Crypt Group 62
Cubism 7, 10, 17, 20, 24, 25, 27, 35, 38, 51, 53, 58, 60, 62, 63, 68, 71–2
Cumbria 7, 16

D

December 5, 1949 (poisonous yellow) 29, 51; fig.23
December 1933 (first completed relief) 36–7; fig.33
December 1955 (night façade) 61; fig.55
Derain, André 13
Dixon, Andrew Graham 65
Dobson, Frank 13
Documenta III relief wall 33; fig.29
Doesburg, Theo van 25
Dorment, Richard 74
drawings 7, 25, 35, 49, 51

E

Eddington, Sir Arthur 47
Ede, Jim 42–3, 46
Evans, Myfanwy see Piper, Myfanwy

F

Fauvism 27
Feb 28–53 (vertical seconds) 53; fig.52
Feb 1960 (ice-off-blue) 31; fig.26
Frost, Terry 28, 64
Green, Black and White Movement fig.57
Fry, Roger 17, 38, 48

G

Gabo, Naum 26–7, 41–2, 49, 62
Gainsborough, Thomas 62
Gardiner, Margaret 9, 49
Garlake, Margaret 64
Geerts, Robert 62
Geometric abstraction 24, 35, 41, 48
'George and Rufus' illustrations 50
Gertler, Mark 11
Giacometti, Alberto 24, 25
Giotto 13
Grigson, Geoffrey 41
Gropius, Walter 35, 41

H

Hampstead 6, 7, 19, 25–6, 50
Harrison, Charles 6, 65
Hélion, Jean 24, 26, 41, 42
Hepworth, Barbara (second wife) 36–8, 47, 49; fig.16
marriage 7, 10, 19–21, 24–31, 34
Pierced Form fig.32
sculptures 9, 25, 26, 28, 30, 32, 33, 36–8, 60, 62, 64, 67, 69
Herbert, George 70
Heron, Patrick 6, 28, 51, 59–60, 63–4
Hilton, Roger 28, 64
Hitchens, Ivon 16, 44

I

International Guggenheim Painting Competition 29
International Style 41
Irving, Henry 10
Italy 13, 16

J

Januszczak, Waldemar 35
Japanese aesthetics 70–3
July 22–47 (still life – Odyssey 1) 53; fig.50
June 4–52 (tableform) 53; fig.47
June 1937 (painting) 25; fig.20
Juniper, Andrew 70

K

Kahnweiler, Daniel-Henri 21
Kandinsky, Wassily 46
Khoroche, Peter 65
Kipling, Rudyard 10
Klee, Paul 71
Kokei, Kobayashi
Fruit 72; fig.66

L

landscapes 27–8, 35, 49–51, 64
Lanyon, Peter 28, 62–3, 64
Larcher, Barron 43
Larcher, Phyllis 43
Lauder, James Eckford 11
Lauder, Scott 11
Le Corbusier 25, 41
Leach, Bernard 8, 43–4, 71, 73
Legge, Rhoda 29
Lewis, David 51
Lewison, Jeremy 6, 7, 17, 42, 46, 51, 53
linocuts 37
Lucas, Colin 41
Lutyens, Edwin 10

M

Martin, Leslie 26, 34, 42
Marx, Enid 43
Matisse, Henri 13
May 1957 (Siena Campanile) fig.27
Mellis, Margaret 27, 62
Mies van der Rohe, Ludwig 35
Miró, Joan 24, 38, 72
modernism 6, 7, 10, 19, 32, 42–6
international 7, 10, 35–6, 41–3, 51
Moholy-Nagy, László 24
Mondrian, Piet 10, 24, 25, 26, 27, 35, 38, 41, 46, 62, 65
Moore, Henry 19, 28, 32, 33, 36, 38, 60, 67, 69
Morris, Guido 62–3
Murray, William Staite 43

N

Nash, Paul 11, 13, 25, 41, 42, 50, 67
nationalism 42–4
Neo-romanticism 42, 58, 68
Nevinson, C.R.W. 11
Nicholson, Andrew (son) 19
Nicholson, Ben
character 7, 10, 47
children 16, 17, 19, 20, 74; fig.10
death 34
education 11
marriages 7, 12–13, 16–17, 19–20, 29–31, 34, 74
parents 8, 10–12; figs. 2, 3
Nicholson, Jake (son) 16, 17; fig.10
Nicholson, Kate (daughter) 19

Nicholson, Mabel (mother) 8, 10–12, 44, 69–70, 74; fig.3
Nicholson, Rachel (daughter) 34
Nicholson, Tony (brother) 11
Nicholson, Sir William (father) 10–12, 13, 29, 44, 46, 65, 74; fig.2
The Lowestoft Bowl 12; fig.5
Nicholson, Winifred (first wife) 7, 12–13, 16–17, 19, 20–1, 25, 30, 34, 37, 44, 46–7, 74; figs.6, 10
Cyclamen and Primula 13; fig.7
'Notes on Abstract Art' 50
November 11–47 (Mousehole) 53; fig.49

O

October 20 1951 (St Ives harbour from Trezion) fig.56
Order of Merit (OM) 33–4

P

painting technique 17, 19
primer 19, 46, 66
surface texture 8, 19, 66–70, 73
Paris 7, 13, 17, 20–1, 24–5, 35, 36–7, 41
Pasmore, Victor 58
Penwith Society of Arts 28, 62–3
Pevsner, Antoine 38
Picasso, Pablo 13, 17, 20, 24, 58, 63, 66, 71–2
Piero della Francesca 13, 65
Piper, John 26, 68
Piper, Myfanwy 9, 26
Pollock, Jackson 69
Pre-Raphaelites 12
primitivism, pursuit of 13, 19, 43, 48, 66–7, 69
Pryde, James 11; fig.2
Pryde, Mabel see Nicholson, Mabel
Purism 24

R

Rafael 71
Ray, Man 24
Read, Herbert 11–12, 26, 32, 34, 36, 38, 41, 42, 43–4, 50, 59, 60, 62
realism 49–50, 58–62
Reddihough, Cyril 9, 12, 44
reliefs 9, 21, 25, 31–4, 49, 51, 69
concrete walls 33; fig.29
white 6, 7, 25, 26, 35–48, 65
Roberts, Charles 12
Roberts, Wilfred 66
Roberts, William 11
Roberts, Winifred see Nicholson, Winifred
Rothenstein, John 8, 59, 65
Rousseau, Henri 13
Russell, John 32, 33, 35, 58, 70

S

Sackville, Lady 10
St Ives 8, 19, 27–31, 49–64
St Ives School 6, 60, 62–4
St Ives Society of Artists 62
Seven and Five Society 6, 16, 26, 41, 44, 62
Sickert, Walter 10

Slade School of Art 11
social realism 58
Somerville, Lillian 61
Spencer, Stanley 11
spirituality in Nicholson's work 7, 8, 46–8, 70–2
Stephens, Chris 36, 43, 44
still-lifes 12, 25, 27–8, 35, 49, 51–8, 61–2, 63–4, 68
Stokes, Adrian 25, 27, 34, 41, 67
studio pottery 8, 43, 71, 73
Summerson, John 11
Surrealism 24, 26
Sutherland, Helen 19
Switzerland 7, 31–4, 64
Sylvester, David 59

T

tachisme 58
Tatlin, Vladimir 27
Tempest, Marie 10
Ticino 13, 16, 31
Tobey, Mark 33
truth to materials, concept of 36–7, 43, 67
Turner, J.M.W. 62

U

Unit One 25–6, 46–7

V

Venice Biennale 28, 30
Verren Taunt, Angela 34, 70
Villa Capriccio 13, 16
Vogler, Felicitas (third wife) 7, 30–1, 34, 64; fig.24
Vorticism 36

W

wabi sabi 8, 71, 73
Wadsworth, Edward 11
Wallis, Alfred 19, 43, 48, 65, 66–7
Two-Masted Ship fig.13
Wells, John 60, 62
white, Nicholson's use of 46
white reliefs 6, 7, 25, 26, 35–48, 65
Wilson, Andrew 46
Wood, Christopher 16, 17, 19, 44, 66, 74; fig.10
Dahlias and Larkspur fig.61
World War I 11
World War II 27, 49, 61, 74
Worringer, Wilhelm 60
Wortley, Edith Stuart 11
Wynter, Bryan 62

Y

Yanagi, Soetsu 71, 73